MEN OF STYLE

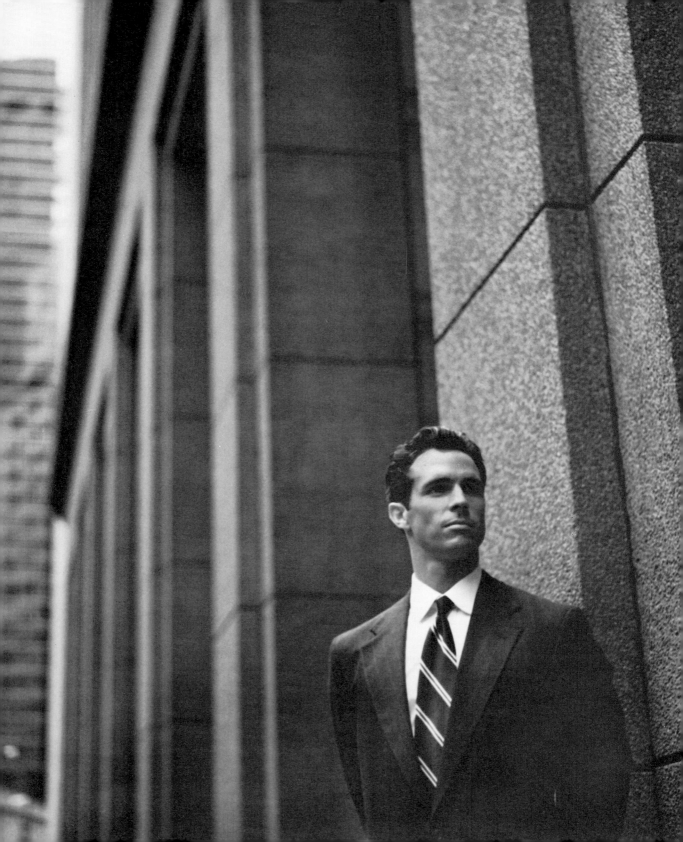

MEN OF STYLE

The Zoli Guide for the Total Man

Donald Charles Richardson

with photographs by John Falocco

Villard Books

New York

1992

Library of Congress Cataloging-in-Publication Data
Richardson, Donald Charles.
Men of style: the Zoli guide for the total man/Donald Charles
Richardson; photographs by John Falocco.
p. cm.
Includes index.
ISBN 0-679-41211-5
1. Men's clothing. 2. Grooming for men. I. Zoli (Firm)
II. Title.
TT617.R53 1992
646.7′044—dc20 92-53659

Manufactured in the United States of America
Designed by J. K. Lambert

9 8 7 6 5 4 3 2

First edition

Photographer: John Falocco

Illustrator: Bryan Grey

Head Stylist: Lisa Young

Stylists: Stacy Boyer, Timothy Reukauf; Associate: Allison Fritz

Hair, makeup, and grooming: Gareth Green

Floral arrangements: Devon Moore

Still-life stylist: Stacy Boyer

Fitness consultant: Dr. Thomas Leveillee

For the Zoli models who, during the course of this project,
consistently exemplified wit, taste, patience, and above all, great style . . .
just as, so many years before, Zoli intended they should

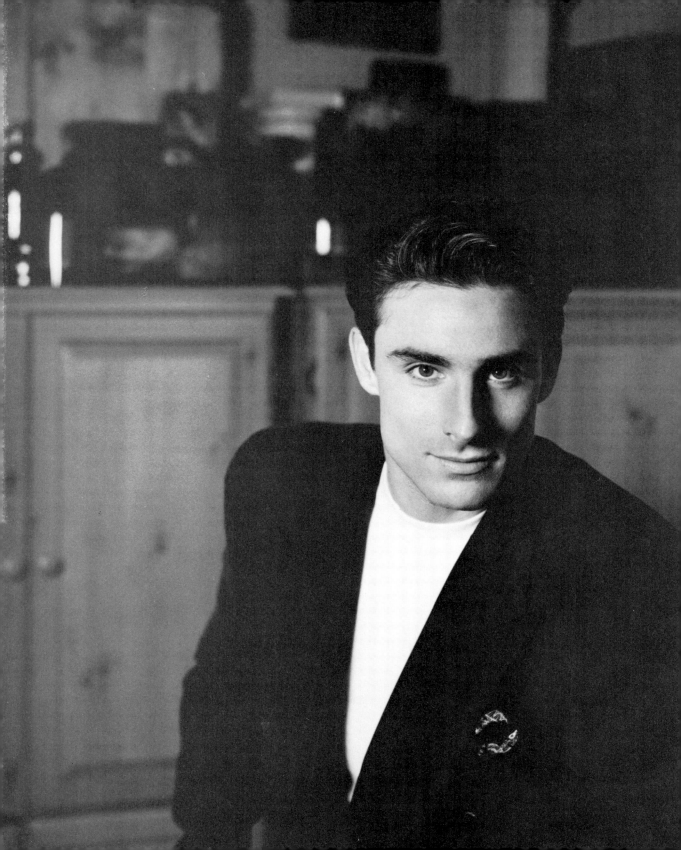

Author's Note

This is not a "model manual." The reader won't discover directions on how to put together a portfolio, find an agent, or make it big in the fashion business. Rather, *Men of Style* is a book designed and directed toward helping every man, individually, create and assume a sense of style and taste, look his best, and get the most out of his appearance, utilizing the means and methods I've discovered through the years working with models, reporting about and creating fitness programs, investigating grooming techniques, and covering the men's fashion business.

Periodically, I've suggested to various publications that we do a piece about what it takes for a model to look the way he does in magazine photo layouts. It seemed to me it would be a good idea to let the reader in on what goes on behind the scenes in the creation of the perfect images that fill advertising and editorial pages. The magazines have consistently rejected the idea, pointing out that such an article would "kill the fantasy." After all, the editors and advertisers design their expensive layouts to convince the reader that if he invests in a particular shirt, cologne, workout routine, shave cream, or skin-care line, he'll look exactly like the ad, have incredible luck with women, and scale mountains.

The truth of the matter is simply that no one, including the models themselves, can look the way men do in the glossy pictures . . . unless, of course, they travel around with a full complement of hairstylists, makeup artists, and lighting technicians hauling a huge collection of equipment . . . to say nothing of an art director, several assistants, and on and on.

Now, don't get me wrong. Most of the men who model *are* good-looking. But their fortune truly lies in their affinity to the camera, their photogenic quality. The persona they portray in the magazines is created, controlled, and

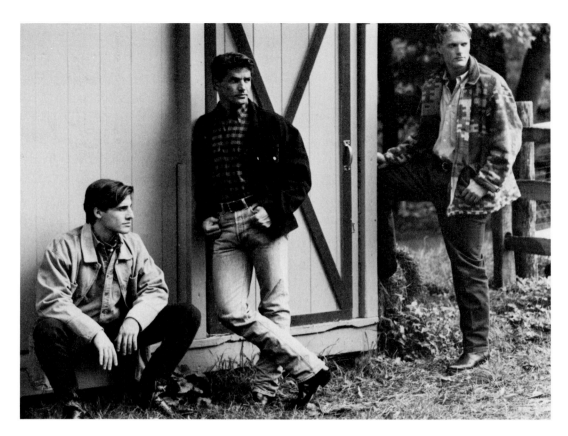

manipulated by people you never see and almost never hear about. Of course, you can learn something about personal presentation from looking at a picture—but the real secrets to looking great are possessed by the quietly efficient individuals who run the show from behind the scenes.

What is the point of all this? Well, it boils down to the simple fact that while the myth may not be reality, the reality is even better. Although *no* man can truly look "like a picture," virtually every man has it in him to look great. And looking great can lead to getting more out of life.

While no one really likes to admit it, the fact remains that men who look good *are* treated differently from those who are overweight, out of shape, or dressed badly. You've probably seen them get the plum jobs and extra at-

tention at parties and wondered, "Just what does he have that I don't?" Actually, nothing. Sure, some guys are born great looking. But others have learned to make the most of themselves. And chances are they're every bit as attractive as anyone who happens to have good genes.

Most men, both models and others, who really look sharp are usually quiet about the whole thing. It's one of those endeavors that separate the sexes. While women like to talk about their hairstyle, latest diet, or most recent shopping trip, men prefer to just get the whole thing done and forget about it. The average man really doesn't want to discuss his workout routine, shaving ritual, or shopping trips. These are things he most likely does under duress, knocks off as quickly as possible, and puts out of his mind. What he wants

to talk about are the results . . . the marathon he is able to run, the sports he plays, the women (or particular woman) he meets and attracts.

Admittedly, having a great body, good skin, and a sharp wardrobe will not, on their own, assure any man of complete professional and social success. A good personality also helps. And no amount of exercise, skin care, or shopping will overcome an obnoxious attitude. In fact, the better you look, the more important it is to think about what you say and do. Otherwise you wind up being one of those people about whom they say, "Looks great . . . but what an idiot."

But this book isn't about developing a personality. It's about getting your look together. And it can do it, if you're willing to make the effort and put aside some old notions and stubborn prejudices, such as the ever-annoying "I like my clothes (hair, skin, body) this way." Well, in all honesty, no one gives a damn what you like. If it's wrong, it's wrong. If cheap-looking clothes, greasy food, and the latest, most absurd haircut make you happy, then be happy . . . but you'll never be a man of style.

For every achievement, there's a sacrifice. And if you have to give up your lousy taste in order to look good, then do it. Otherwise, you're just wasting your time.

And there's one other thing: You have to learn to separate yourself from your ego. It's strange that most men can take criticism of their work, or their sporting ability, but tell a guy he's got a bad haircut or is wearing an ugly suit, and he's insulted. To get the best out of your appearance you have to be as subjective as possible, taking the hits and misses as a part of your learning experience. And since the whole thing is so simple (once you get it all down) in no time at all you'll be able to pick on somebody else.

It is important to note that learning and practicing the basics of style don't automatically require a man to abandon all his individ-uality. Rather, the point of assuming good fitness and grooming practices and selecting the right wardrobe is to place each man's appearance in the proper perspective so it doesn't intrude on his personality or distract from his unique individual qualities.

Every once in a while, a small voice will cry out that there doesn't seem to be any style left in the world anymore. We're surrounded with fast-food restaurants, trendy garments, bad manners, and an apparently overwhelming need on the part of many to "express" themselves by wearing or doing ridiculous things. Don't be fooled by the obvious. There are still little pockets of style out there, individuals who certainly may not turn heads when they walk into a room, but nonetheless are the people most everyone eventually gravitates to after they've gotten bored with the "glamour types." Call it a sense of security, an aura of stability, but whatever you call it it's the kind of thing that sets a man apart in the most flattering way possible. Not because he's unusual,

enough to let his clothes, haircut, or body do his talking for him.

One model agent once told me that the perfect model always, despite what other attributes he possesses, looks "to the manner born." By this, she meant that the potentially money-making male model needs that overworked, misused, and truly disgusting word, "class." He must give the impression of strength, solidity, elegance, intelligence, and self-confidence, projecting an air of comfort (whether he feels it or not) in his clothes and with his looks.

Over time I've run across some truly interesting and handsome innovations in men's clothes and also effective and viable hair- and skin-care discoveries. I've also been witness to some of the most mindless, bizarre, and non-sensical fashion and grooming endeavors any man could have the misfortune to encounter. At times, the ridiculous and the excellent have been very close together. In the final analysis, all these experiences have made it possible for me to tell the difference between a valid and functional fashion or personal grooming innovation and a stupid unproductive rip-off.

I'm hopeful the information in this book will help you know the difference as well. Once you do, you'll be well on your way to creating your own look, your own identity within the framework of a man of style.

but because he's simply got it all together. There's nothing freakish or shocking about him, he's just a complete package. He's the man who either instinctively or perhaps through practice has discovered the secret. A man's personal presentation, body, face, haircut, clothes, are a *backdrop* for him . . . they're not who he is. And he's not silly

Foreword
About the Zoli Agency

Zoli Management, Inc., was created in 1970 by Zoltan Rendessy, known as Zoli. He had spent most of his adult life working in the modeling business and he came up with an idea at exactly the right time and place. The new Zoli Agency wasn't to be just another model management company. Zoli was determined to make male models as important, sought after, and well paid as female models. It was an almost revolutionary concept. And it required an enormous amount of patience, care, energy, and foresight to pull it off. Making use of his European and American contacts, Zoli brought together a unique, varied, vital collection of men. The new organization received immediate attention and became, virtually overnight, the most important men's agency in the world.

Zoli also carefully chose a creative and hardworking staff with whom he established a firm, family feeling. Zoli's association with the people who worked for the agency was so close that on his death in 1982, it was no surprise to discover he'd left his agency to Barbara Lantz and Vicky Pribble, two of his most loyal and hardworking employees. And under their leadership, the Zoli Agency has continued to hold its position as the top men's management organization.

The Zoli men have worked for every designer, fashion magazine, and ad agency. Their images have appeared on billboards and in countless catalogs. There are Zoli men working across the United States and in Europe. But it's not only as representatives of a designer or product that the Zoli men are known. They have a mystique all their own. The Zoli man is so recognizable, in fact, that when Fred Weisman did his documentary on the modeling business for PBS, he chose Zoli models exclusively for the project.

"The Zoli Agency has made men first-class

citizens in the modeling business," says Pribble. "We didn't do that by just finding good-looking guys and getting them jobs. We've stayed on top because we've always anticipated the trends, been ahead of the changes. Today's image of the male model as a healthy, fit, confident man is the ultimate result of all the years we've spent working and opening up the business." Lantz continues, "We create them . . . the look, the style. . . . We guide and advise our men on their grooming, how to take care of themselves . . . dress, exercise, eat. . . . Sometimes they just need a shoulder to lean on. That's part of our job, too."

The Zoli men were chosen for *Men of Style* not just because they're good-looking, but also because they are marvelous mirror images of today's men. Sharp, solid, and smart, they range in age from their early twenties to their fifties, and have a variety of interests. Many are married and have families; they all face the worries and concerns of any contemporary male. And, contrary to misguided public perception, they don't spend hours in front of a mirror looking for blemishes and trying to hide tiny lines. However, what they have done and what the average man can also do, is simply taken the time to look their best so they can get the most out of the rest of their lives. And that's really what it's all about.

The Zoli Agency

Barbara Lantz, President
Victoria Pribble, Executive Vice-President

Men's Division

Roseanne Vecchione, Director
Renata White
Heidi Belman
Bob Van Riper
Maria Logozzo

Women's Division

Rosemarie Chalem, Director
Paul Blascak
Joanne Gunton
Marilyn Ballard

Illusions and Style

Susan Branagon-Gilbert
Lelia Raibourn Carr-Forster

Acknowledgments

A lot of individuals contributed their talent and energy to *Men of Style.* I would particularly like to thank the staff, bookers, and models of the Zoli agency and the backbone crew of the book, Lisa Young, Stacy Boyer, Timothy Reukauf, Gareth Green, and Dr. Thomas Leveillee for their time, effort, and creativity. In addition, many members of the men's fashion community and makers of grooming products, Mary Ellen Barone, Georgia Allen, Erin Gaffney, Susan Dionne, Erica Feinberg, Jan Goldberg, Gary Shanil, Charles Burkhalter, Ellen Dux, Vera Brown, Seth Cloutman, Bob Macleod, Steve Bychiavicz, and John Mead worked tirelessly to provide the right clothes and products for the photographs. Other individuals continued, with this project, their constant and ongoing support and enthusiasm: Pieter O'Brien, Cheh Nam Low, Steve Downs, Tommy Hilfiger, Molly Falocco, Steve Herman, M.D., Roseanne Vecchione, Sylvia Scott, Merrill Sindler, Alfred Lopez, Barry Van Lenten, and, of course, my agent, Harvey Klinger.

The truly wonderful artistic and professional contributions of editor Emily Bestler, art director Richard Aquan, and designer Jim Lambert, who sensitively and imaginatively molded this project, are clearly evident, as are the photographs of John Falocco, whose work is not only demonstrative of style, but proof of this quality.

Contents

Part III / The Hair

Part IV / The Clothes

Part V / It's Your Turn

Introduction
It's All a Matter of Style

This is a book about power . . . personal power. If you get nothing else from *Men of Style,* at least become aware of and always remember that, despite all the efforts on the part of corporate structures, social movements, and media hype, you are an individual. And when it comes to the way you look, you're in charge. It is your body, face, hair, clothes that are being discussed.

The point of this book is to provide you with the basics, the ins and outs of looking your best, to give you the essentials and guide you in the right direction so that when you're out on your own you'll make intelligent and constructive choices.

There is a constant barrage from the media of surefire answers to all your problems. All you have to do is wear a particular shirt, smell a particular way, or use a particular workout program and the manufacturers guarantee you a beautiful life. Well, that's all very nice . . . and naturally most men are glad that anyone gives a damn about them. But in point of fact, the problem with most of the suggestions so creatively propounded by marketing experts is that their solutions are all generic. And men aren't. Men are individuals with individual physical characteristics (positive and negative) and, of course, their own goals.

There's nothing you can't be. Periodically, it's fashionable to point out that the outer man is not nearly as important as the inner man. Philosophically this is a perfectly valid observation. However, it's often difficult to really get a chance to show the inner man if the outer one is a mess. And don't discount the feeling of self-confidence that comes from knowing that you're dressed and groomed to perfection, ready for whatever social or professional challenges you face.

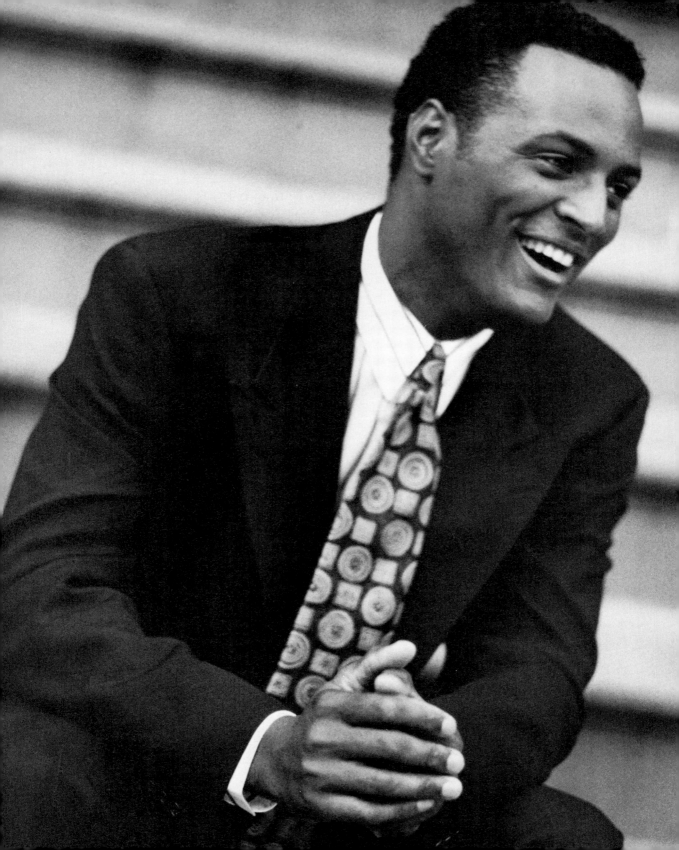

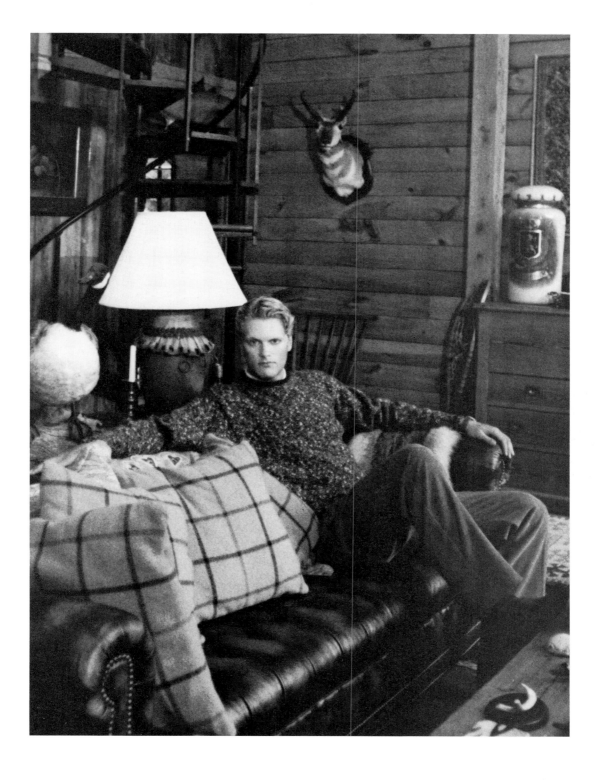

Besides, what's so great about being yourself . . . when you consider that you can be anything or anyone you want? A little work here, a little there, and chances are you can be a whole new you with all the benefits associated with achieving personal goals.

At about this point, the average man is probably ready to toss this book in the air, convinced he could do all this if he was some rich guy who had nothing else to think of but his body and wardrobe. Actually, looking your best *has nothing to do with money*. In reality, money can be the death of taste. For some reason, people who have acquired an immense amount of cash (particularly those who don't have a history of living with real money) appear to be under the impression that they can pretty much do what they want when it comes to the way they look. This is, of course, nonsense. But setting aside (or perhaps just forgetting) the nouveau riche, there is a benefit to shopping on a budget, simply because limiting the amount of money that can be spent on haircuts, skin-care supplies, and clothes requires a man to buy intelligently if he really wants to look his best.

Style. This is what it's all about. Style always remains the same . . . an indefinable quality that sets some individuals apart, and makes them special, unique. Style is not limited to clothes . . . it includes all the aspects of a man's personal presentation, coming together to create a total look, a completeness that means all the elements are working in harmony. Having style is essentially a personality trait, like having a sense of humor, being a good organizer, or working well with other people. Some people have these attributes naturally. But just as an individual can develop a sense of humor, study organization, and practice his interpersonal relationship skills, he can also learn a sense of style.

It needs to be understood that there is a dramatic difference between having style and being "in style" or "stylish." Wearing or doing whatever is in style doesn't mean that you have style. In fact, the opposite may be true. If you're a man of style, chances are you'll never get a compliment on your clothes, hair, or body. All of these things are a part of your personal presentation (remember this term), but they are a backdrop for you. They are not, and never should be, what people see when you walk into a room. They should see *you*. No particular aspect of you—*you*.

The idea that clothes make the man is fine if you're willing to act as a coat hanger. Most men aren't interested in simply showing off some fashion designer's midnight inspiration. And they shouldn't be. The man of style wears his clothes, carries his body, and combs his hair as if none of it matters. And he can do that because he's spent time making sure he's got the essentials down so he doesn't have to worry about them anymore. It also should be noted that no man who truly cares about the way he looks tries to duplicate someone else. Before he can have style, he has to be his own man, capable of making personal decisions and aware of what helps him reach his own ultimate physical potential.

Becoming a man of style is well worth the effort; financially, ecologically, socially, professionally, and personally. Financially, the man of style saves by not wasting money on trends or fads; he is ecologically correct because he buys natural-fabric clothes, skin-care products that don't harm the environment (these are often considerably less expensive than the high-priced department store products that bank on expensive sales campaigns and packaging); socially, because he's always dressed appropriately and looks nice, regardless of the occasion; professionally, because he makes a good image for his business; and personally, because nothing builds self-confidence faster than being sure you look your best.

Think of *Men of Style* as your guide to a makeover, the means and methods by which you can take one aspect of your life—your personal presentation—get it under control,

make sure it's right, and forget about it. In many cases you probably won't be doing anything you're not already doing . . . you'll just be doing them more productively.

And when you've got it all down, you might find yourself in a whole new world. At the very least you'll feel a lot better about yourself . . . and that alone is worth the effort.

PART I

The Body

"Well, I could have a great body if I weren't so busy . . . if I didn't have to work so hard or have so many calls on my time . . . if I weren't so tired . . . I'm a little old for all that now . . . I'll join a gym real soon. . . ."

You can probably add a few more excuses if you really put your mind to it. But the fact is that for any man really interested in being and looking his best, body care is not something that can be pushed aside or ignored. It's a requirement.

Think of creating your look as you would think of any other important task, such as building a house or putting together a new business. Your body is the groundwork, the bottom line upon which everything else depends. Taking care of your skin, eating properly, carrying yourself well, and working out are the basics of looking your best.

So, to that end, it's a good idea to start at the beginning with exercise.

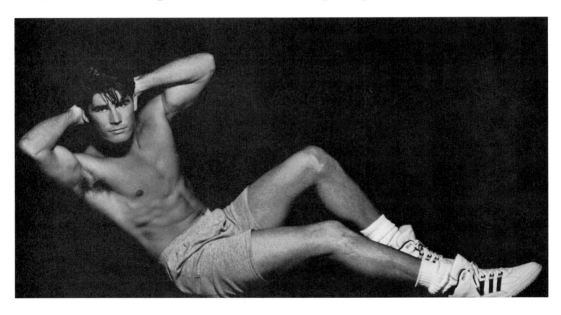

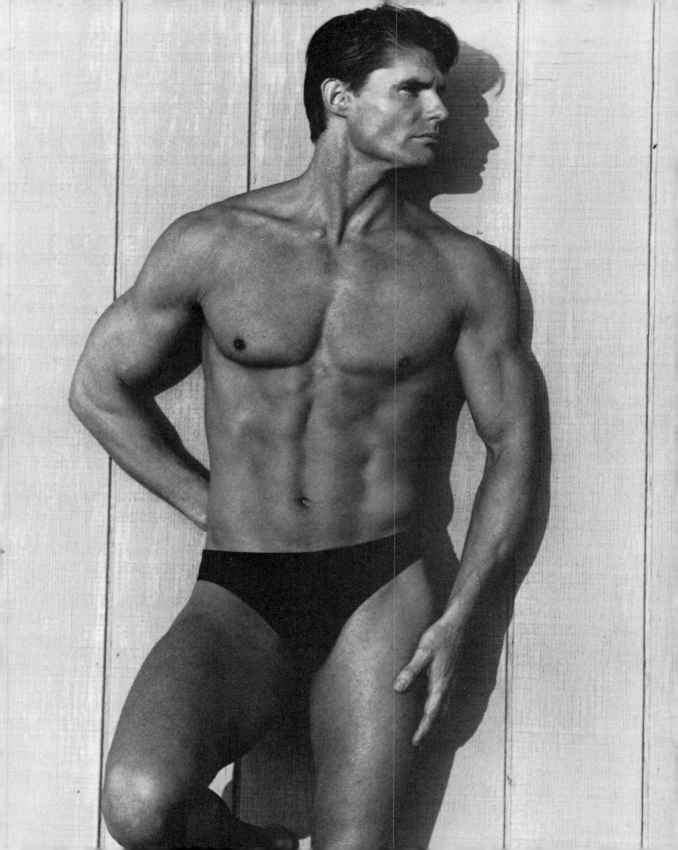

Chapter 1

Exercise

Certainly exercise is, or should be, an integral part of every man's regular self-care routine. Chances are you already know that exercise is good for you, that it keeps the body running well, helps it look its best, and generally adds a healthier dimension to every existence.

A lot of men go to the gym to make their bodies more attractive, and the fact that they get healthier in the process is an added benefit. However, if you are truly going to the gym to keep your body healthy, more power to you. Why you go isn't important so long as you *go*. There's no excuse not to be engaged in some kind of ongoing workout activity. The question is what kind of exercise should you do?

There have always been a lot of choices. And as more scientific evidence is uncovered, greater advances made in physiology, and new developments in equipment produced, the fitness market is likely to get increasingly con-fusing. Walk or climb, run or step, lift or stretch, get your heart rate up, keep it down, bounce, don't bounce, slightly bounce. Along with advice from scientists, there are fitness gurus selling their particular methods, and exercise experts convinced they have the answer. One individual will claim that aerobics solve all problems, another insists that weight training is the key, and yet a third will promise that using particular machines provides the perfect workout. What no one seems to want to admit is that there is simply no such thing as one answer for everyone. It just doesn't make sense for a man of forty to work his body the same way a man of twenty does, or for one guy in good shape to do the same things a man in bad shape needs to do—to say nothing of the idea that busy business people should spend as much time in a gym as the guy who doesn't have those kinds of professional responsibilities.

The intelligent man works *his* body, taking the time first to determine several important and too often overlooked individual characteristics. It is both counterproductive and frustrating to work "against the body."

There are two basic concepts that should determine your workout program: What do you have to work with, and what do you want to look like?

First, consider the current condition of your body (fat, thin, flabby, heavy in some areas, light in others), any physical limitations you have (muscular strength, illnesses, conditions that have to be considered), and your schedule (to jump into a huge exercise program at the same time you're undertaking a new job is ridiculous; the workout routine has to work with the rest of your life).

Self-analysis is also important simply because the kind of physique you have determines what kind of good-looking body you can

most easily achieve. For example, some men have genetically longer muscles, others have shorter ones. (This difference does not necessarily depend on the height of an individual but rather on his type of build.) Short muscles will usually respond more quickly to anaerobic exercise, gaining bulk and size more rapidly than long muscles. However, long muscles are most often easier to define and tone. If your body isn't genetically programmed to create or carry a big muscular body, it's counterproductive to devote time and energy attempting to build a super-size physique when a superb slim body is much easier to attain and every bit as handsome.

If you do have the inherent muscularity that responds to heavy weight lifting and you want to create a big body, then go for it. The point is simply that you can have a great body regardless of what kind of muscle structure you possess. To get your body to its greatest potential, you have to work within the framework of your individual physique and create your own workout routine based on your own body.

The first thing you have to do before even starting to think about exercise is learn about yourself.

LEARNING ABOUT YOUR BODY

Every man has distinct and individual positive and negative physical aspects to his body. These factors determine both the kind of exercise he should do and the type of physique he should direct his workout toward.

To find out about your body and the shape it's in, you have a choice. You can, if you're truly objective, simply stare at yourself nude in a mirror, taking stock of what you see. Is your gut protruding, legs skinny and weak, arms flabby? Then be ruthless and make notes about the bad things you see . . . as well as the good.

Unfortunately, this process doesn't work for everyone. Some men have an astonishing abil-

ity to ignore the obvious and delude themselves into thinking they look great. Too often, men can glance at their out-of-shape bodies, flex their arm muscles (such as they are), and nod approvingly. (These are often the same guys who hang out at singles' bars wearing open shirts, gold chains, and too much aftershave.)

There's no way anyone can convince a man, locked in his own misguided ego, that he needs to get to work on himself. But chances are any man who's convinced he looks perfect isn't reading now anyway.

Perhaps one of the best tools in self-evaluation is a tape measure. If you can't, or won't, really see what's right and what's wrong with your body, the tape will tell you the truth.

Measure your biceps (flexed), chest (not ex-

panded), stomach (not sucked in), hips, thighs, and calves. A rule of thumb for a well-toned, slender body is that your chest should be eight to ten inches larger than your stomach, your hips five to eight inches larger than your stomach, your biceps and calves the same measurement, and your thighs seven inches larger than your calves. Naturally, these measurements are going to vary depending on individual body structures and, of course, if you have an enormous waistline, you wouldn't opt to enlarge the chest to make it come into balance; rather you'd reduce the stomach area to an appropriate size. (If you happen to have these exact measurements, you're perfect and can go on to the next chapter.) It should be noted that there's nothing wrong with combining the visual assessment and measuring methods if it

helps you get a good grasp on the condition of your individual physique.

However, if you find that the whole self-assessment endeavor is just too much for you to deal with, then your only alternative is to ask for help from a professional trainer or fitness expert. But before you go, you have to establish the second priority of getting into shape.

Now that you have determined your current condition, what do you want to look like? This point calls for *exact* physical goals. You can't plan a trip until you know what your destination is. And you can't get your body in shape until you have an idea of what you'd like the results to be.

If you decide to meet with a fitness professional, don't just sit down and say, "I want to

look good." The problem with this attitude is twofold. First, you have immediately lost control of your whole exercise routine; and second, the way the fitness expert views you may be totally different from the way you view yourself. The end result could be an exercise program that works your body in a direction that is completely opposite to the way you want it to come out.

You've looked yourself over and regardless of how uninformed you might be about exercise and fitness, you have, somewhere in the back of your mind, priorities and thoughts about how you'd like to look. Perhaps you want to lose weight, or maybe put on a few pounds. To some guys, a great stomach is an indication of a great body; for others, big shoulders and arms are what it's all about. So make sure the fitness instructor is aware of what direction you want to go. Or, if you're working on your own, always keep your goals in mind when you choose a particular type of exercise to include in your workout.

The last thing in the world you need is a generic routine. You want one designed for you, nobody else. Naturally, this doesn't mean that you won't be doing some of the same exercises as others, but you might be doing them in a different manner, perhaps using lighter resistance, or maybe fewer repetitions. The point is that the whole thing should be directed toward your own goals.

The basics of exercise are simple, breaking down into four categories: aerobic, anaerobic, calisthenic, and stretches. Condition the body with aerobics, tone it with machines, sculpt it with free-weights, and keep it limber with stretches.

EXERCISE CHOICES

Aerobic

Aerobics include activities such as dancing, running, walking, and climbing; either without

the blood flowing; consequently, the food an individual takes in is used as energy, rather than stored as fat. It must be noted, however, that exercise alone will not cause an individual to lose weight. An intelligent diet is also required.

Anaerobic

Anaerobic exercise is designed to build muscle. Despite the advances in weight-resistance machines, most men who have created really strong, muscular bodies have most likely used free weights because they require greater control and personal effort on the part of the athlete. Machines are excellent for toning the body, but few really "show-off" bodies depend on machines for muscularity. It is possible to build some muscle on machines. But if you're totally dedicated to creating a bulky body or sculpted muscles, chances are you'll have to include a vigorous free-weight program. It should be noted, however, that because free

equipment or utilizing machines. They are excellent for cardiovascular work, increasing the heart rate and blood flow. This form of exercise can get the body moving, and feeling more alive, and relieve stress. Aerobics are considered the healthiest form of exercise by many fitness authorities simply because they get the heart rate up and thus increase the strength of the cardiovascular system. Individuals interested in losing weight usually find aerobics the most difficult and the most rewarding routines. The body is somewhat like a stone. When it's settled, unmoving, it tends to remain in this position. However, once it starts to move, the inclination is for it to continue moving. This is the reason aerobics are helpful in weight loss. In reality, the amount of weight an individual actually takes off during aerobic activity is minimal (you would have to run, walk, jump, or dance many miles in order to lose just one pound). But once the body gets warmed up and starts to be active, it continues in this mode, the heart beating healthily and

weights are considered more dangerous to handle and manipulate than machines, insurance companies have raised the premiums on this form of equipment. So, some gyms have moved toward the elimination of free weights, concentrating on machines instead.

While aerobics can be very frustrating for some individuals, anaerobic exercise is, without question, the least productive type of exercise if done improperly or "against the body." There are men who spend years working out without any noticeable achievement or change. This can be due to one of several factors.

For example, if a man is attempting to build his arms and chooses free weights (dumbbells) for the process, he could be defeating himself simply by "cheating." He may use a weight that is too light to actually force the muscle to respond and build. Or he may not take the exercise through its complete range of motion, thus removing much of the benefit of the procedure. He may even employ other muscles to help do the movement, which negates the concentration of the exercise.

Weight-resistant exercises, particularly those using free weights, must be done intelligently and sensibly, otherwise the results are limited and the procedure can actually be dangerous (nothing is worse than watching a man doing standing barbell curls for his arms, allowing his back to assume the bulk of the resistance; this activity naturally means the arms don't get the benefit of the exercise and can result in serious damage to the back).

By the same token, if a man's body isn't inherently designed for "big" muscles, all the work in the world won't change things; he's much better off using the weights to get the most out of what he has, sculpting and defining the muscles rather than trying to make them huge.

Again, it's individual. Each man must know what he wants his body to look like, which muscles need what kind of training, and what his body is capable of doing.

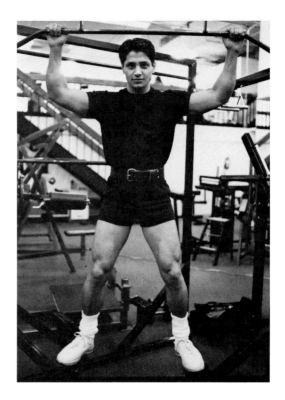

Calisthenics

Calisthenics, which include sit-ups, push-ups, chin-ups, leg lifts, jumping jacks, and trunk twists, can be very beneficial in toning and balancing a body simply because, for the most part, they utilize the resistance provided by an individual's own physique. These exercises can tighten, build, tone, and train the physique; however, they do not build muscles as efficiently as anaerobic exercise, nor do they increase the heart rate as effectively as aerobic routines.

Stretches

Because they are suitable for all body types, stretches are the only universal type of exercise. And besides being beneficial in themselves, stretches are vital to warm up the body before attempting any other form of exercise.

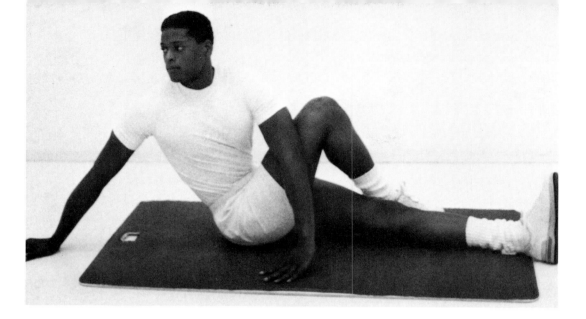

Too often the amateur athlete finds them too time consuming and instead rushes right into his weight-training or aerobic class, thereby running the risk of injury and discomfort. Stretches can not only help a man complete his exercise routine safely, but also make life in general easier simply because stretches help relieve stress, protect the body from strain, and keep the "line" of the body in good shape. Stretch before everything.

Time and time again, fitness authorities have stressed that you should never bounce in a stretch. You should move into a stretch position, hold it for fifteen to twenty seconds and gently release. Why people insist on bouncing in a stretch (which can actually tear the muscle fiber) is a difficult question. Whatever the reason it's dumb, so don't do it.

A Word About the Stomach Society has chosen the stomach as the most visually important muscle group. A superflat, defined stomach can minimize inadequacies in virtually every other body part. However, the stomach muscles are also the hardest to control.

The standard and most popular exercise to achieve a perfect belly is the sit-up. Certainly,

this is one of the best methods for strengthening and tightening the stomach muscle. It is not, however, the best method for flattening the area. In fact, it is possible for an overweight man to do an aerobic workout, eat sensibly, lose his weight, but (if he has done sit-ups throughout his program) still have a large stomach measurement. This result is due to the fact that *sit-ups build the stomach muscles and tighten them where they are.*

This situation is most easily understood by

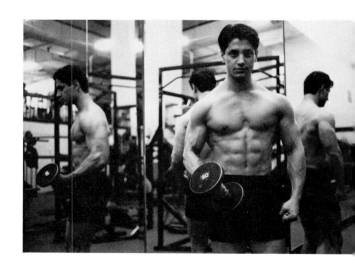

comparing the stomach muscles with the arm muscles. To build the biceps, most men will choose to use a dumbbell, lifting and contracting the muscles, forcing the muscle to build, gain in size, and bulk up. Sit-ups are essentially contraction exercise for the stomach. They tighten, contract and *build* the stomach muscles, making them stronger; but a sit-up, simply because of the action of the movement, can't possibly reduce the size of a stomach.

Until the stomach muscles are behind the rib cage (which they almost never are when an individual is overweight), it is better to do *extension* movements. Exercises such as leg lifts, leg thrusts, and leg scissors are much more conducive to a flat stomach. Once the stomach is flat, a man can do all the sit-ups he wants to tighten and define the area.

A Word About Injury Prevention Of course, any intelligent man has himself checked out by a doctor before leaping into *any* exercise program. But along with this important initial medical assessment, there are regular precau-

tions you can take to make sure you don't hurt yourself.

• If you're *truly* tired (not just feeling "blah") then put your workout off until you've got more energy. Although exercise can give you new energy if you're stressed out, you only run the risk of hurting yourself by trying to do a workout program when you're really worn out.

• Never work out when you have a full stomach. When you're digesting food, the blood flows to your stomach, and you need it heading toward the muscles. So, don't eat and exercise. (This rule reinforces a point in the nutrition Simple Solutions. See page 25.)

• As you mature, your muscles and bones can atrophy and lose some of their resilience. Consequently, an adequate warm-up and stretch period is vital before you actually become involved in aerobics or weight training.

• To make sure you don't hurt yourself during exercise, keep your form perfect at all times regardless of the type of exercise you're doing.

GETTING STARTED

The worst part of any workout routine is actually getting it going. Starting out at the gym requires two essential qualities: purpose and a sense of humor. Without these, there's no way you'll make any progress. Certainly, the beginning of any fitness program is the hardest. You walk into a gym and find yourself standing next to a guy with a great physique or a woman with perfect proportions. You're immediately discouraged and slink out of the facility without having done anything at all.

Take heart. The following steps will help you get over your initial nervousness.

• Have goals firmly in mind. If you're not really aware of what you need to do, find a friend or professional who can help you take stock of your physique. When it comes to fitness (and, incidentally, diets) a firm, intelligent, realistic goal is vital. But—and here's the important part—do not set final goals at the beginning. Rather, establish small goals along the way; reasonable and reachable goals that you're sure you can accomplish.

• Don't worry about dressing right. Be comfortable. One model insists that gym clothes shouldn't match or be too neat. It's the one chance most men have all day of being truly comfortable and colorful. So select garments that make you feel your most relaxed and happy. Heavy men, incidentally, often make the same mistake with their gym clothes that they make with their sport clothes, choosing oversized or extra-thick garments that make them look bigger. Camouflaging excess weight can be accomplished by choosing full-cut workout pants and shirt in medium sizes.

• Ask questions. Personal trainers are great for a lot of people, but they are both expensive and sometimes difficult to arrange. In addition, regardless of how much help you get, the basic responsibility for your body remains with you. It is not always a good idea to abdicate this responsibility to someone else. Many gyms have floor trainers available to help members. In some clubs these individuals are there essentially to sell memberships, but if your contract says that guidance is available, then take advantage of it.

If you can't afford or don't want a personal trainer and your club doesn't have floor trainers, you can still usually find assistance. A lot of men and women who are really into working out are more than happy to give pointers. Naturally, no one wants their own routine constantly interrupted, but if you see someone doing a particular exercise and wonder about it, there's nothing wrong with asking.

You can also hire a personal trainer for one day a week, doing the routine on your own on the other days you work out.

A workout partner is a great idea. Get a friend to meet you at the gym. Having an appointment will help make sure you don't blow off your exercise time. You'll always have someone to talk to, and chances are there will be just a little bit of competition to help both of you keep going.

• Ignore the ignorant. It seems to be the rule that those people who are in the worst shape are the most likely to offer unsolicited advice. Others who are in "all right," but not super condition, are usually the most difficult about

waiting for equipment or holding up others. Don't bother with either of these types.

• Don't try to do everything at once. The most functional workout routine for busy professional men is one that only lasts thirty or forty minutes, at least at the beginning. A full hour or longer just seems like too much of a commitment for many men. But twenty minutes on the treadmill and ten or fifteen minutes going through a machine circuit will provide a good basis from which it is possible for each individual to expand as they get into the whole gym "thing." Chances are as you continue you'll want to spend more time.

• Don't do uncomfortable or embarrassing exercises. Every man needs to take honest stock of what he is and is not willing to do. A lot of men understandably hate aerobic classes. The movements seem silly, the group is usually made up of perfectly formed females, and nothing points up an individual's own imperfections faster than bouncing around a room with a lot of people in great shape. They're wearing tight leotards, you're in shapeless sweats. If you don't want to go to aerobic classes, find another way of getting your heart rate up.

However, if you really want to look good, you might as well accept the fact that chances are you'll have to do a few things you really hate at the gym. The benefit of a fitness trainer or workout partner is that he should be able to convince you to do the exercises necessary to reach *your* goals, even if you can't stand them.

• Learn as many different ways as possible of doing the same thing. There are some days when you simply won't be up to your regular routine or maybe all the equipment you generally use is busy. It's at these times that alternate workout methods are most important. For example, if you're used to using an arm machine for your biceps and triceps and that equipment has a line waiting for it, you should know how to replace the movements with free weights. This kind of alternate training is also good for your physique since regardless of how similar the exercises might be, every piece of equipment and every variation of an exercise acts on the muscle differently, thus contributing to whole muscle development.

Simple Solutions

■ When doing any exercise with an adjustable apparatus (machine), set it properly, then move the seat or bar slightly to increase the effort. For example, most treadmills have elevation controls. When you first begin working out on this apparatus, you'll most likely be concentrating on accomplishing the routine. However, if you move the elevation up to the first point, you won't really notice the difference, but it will nonetheless be helpful in increasing the benefits of the exercise.

■ When it "just isn't working," simply leave the gym. Although many fitness professionals will insist that regardless of what mood you're in you have to do your exercise, there will no doubt be some days when, after suiting up and going onto the workout floor, you lift a weight and realize the gym is the last place on earth you want to be. As long as this doesn't happen regularly you're probably better off getting out. Otherwise, if you force yourself to finish up, you

run the risk of actually doing damage to your body (if your attention is elsewhere) to say nothing of perpetuating the dislike you have for the experience, making it increasingly difficult to get back into your routine.

Industrial-Strength Endeavors

▪ To make arm muscles really bulge, do a regular biceps/triceps workout with free weights. When you've finished, pick up a light-weight barbell and pyramid. The procedure is very simple. Simply stand, holding the barbell with both hands, and curl it up to the chest, lower it, wait the count of five, curl the barbell twice, wait the five count and continue adding a curl until you reach ten repetitions. Then starting at ten, work your way back down. The pump will be incredible.

▪ Set aside one day a month for a "total workout." On this day, give yourself a few hours and really blitz your body. Do your aerobics longer, complete a full-body weight routine, stretch, really push yourself. At the end of this session, you'll be tired, worn out, and totally energized. And you'll look forward to the next session.

Chapter 2

Posture

One of the key benefits of exercise that people rarely notice is the way a well-toned individual holds his body. For example, superb athletes are some of the most graceful people there are. And this is simply because the athlete's body is a well-tuned machine that is totally connected with itself. But even the "not-perfect" body can still move and stand with distinction.

Very few individuals actually think about their posture. After all, if they can stand and get from one place to the next, it hardly seems worthwhile to spend time pondering the manner in which the act is accomplished.

However, posture is important because body language is important. A man reveals a lot about himself by the way he enters a room, stands, and holds his body. Models assume some very strange postures when doing their jobs because most photographers are interested in capturing an unusual, maybe even

shocking, image. However, models don't walk around in peculiar positions; they have to project themselves with the same air of confidence, strength, and reliability that is required from any businessman.

It's not a matter of assuming any particular posture. Your posture should not be enforced on the body. Don't try to relax too much, or assume that standing straight is the answer. Just as standing slumped over and looking hangdog gives the impression of defeat, an iron-rod straight, stiff, and unbending posture

implies awkwardness and inflexibility (unless, of course, you're in the military).

The body looks its best when held in what is essentially the most natural and physically proper positions. To portray power and security, a man should stand with his feet pointed directly forward, his shoulders straight, hands free, and—very important—knees bent half an inch. While removing tension from the back and legs, this slight break gives an energetic thrust to the body, which translates as ease and authority.

Simple Solutions

■ To enter a room looking confident and self-assured, first stand with your heels, butt, shoulders, and head touching a wall. Imagine a string such as that used by puppeteers going right through your skull and down your spine. This exercise will cause you to feel your body coming into line, providing a centering and focus of energy.

■ It's interesting to note that the top male models have a tendency to sit the same way. They don't lean back in their chair (indicating lack of interest) nor perch on the edge of their seat (appear desperate); rather they sit directly in the middle of the chair, body slightly forward, feet firmly on the floor. The next time you're in an important meeting, sit in this fashion. You'll find you can move easily to turn your attention to whoever is talking, appear to be at your ease, and project an aura of strength and intelligent enthusiasm.

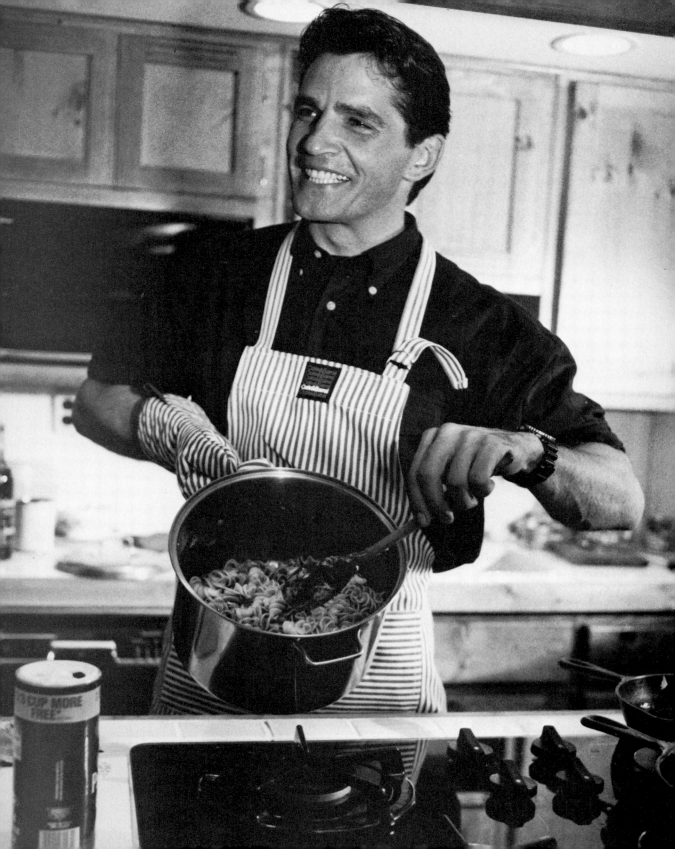

Chapter 3

Nutrition

Every day most men are bombarded with the latest diet information, much of it indicating that what they thought at one time was a perfectly acceptable food actually contains all kinds of dangerous chemicals and compounds that can cause everything from sterility to hair loss. On the other hand, there are also continually occurring nutrition breakthroughs that promise extraordinary benefits from eating the "right" foods. And, of course, there are the purveyors of health, nutrition, and diet, who, just like the fitness fixers, have the surefire answers for weight loss, weight gain, weight maintenance, and healthy eating.

Basically, there are really only two considerations when it comes to nutrition. For the man with no weight problem, the basic idea is to simply eat good food that will support his body, encourage excellent health, give him the energy and stamina to live his life, and generally help him look and feel his best. The man with a weight problem, who either needs to gain or lose weight, has to deal with his individual physiology while providing himself with the necessary nutrients for health.

Nutrition appears to be, for all intents and purposes, a somewhat inexact science. It is possible to find professional athletes stuffing themselves with junk food, still performing and looking great, while some holistic doctors seem to be totally emaciated. The whole reason for these differences is simply individual chemistry, age, and the physical demands you may or may not place on yourself. If you run two miles every day, work out, and spend hours training, then chances are you can eat some garbage and not do yourself any harm; of course, you may not be doing yourself any good, either. However, the average man who works out, goes to his job, and has a family and a social life isn't likely to be able to handle eating poorly and still look and feel his best.

One of the most peculiar things many men do is "treat" themselves with some kind of junk food. Why anyone would think that they "deserve" to do damage to themselves is very difficult to understand. You've had a rough day, worked hard, had a lot of stress and strain, things aren't great at home. . . . So you crash in front of the television set and eat a bag of potato chips? Even if it appears that no one else gives a damn about you, the idea that you don't care either just doesn't make any sense. A man who really wants to treat himself does so not by eating garbage but by eating something that's good for him.

The diet discussion is yet another "sex separator." Women don't seem to mind talking about their newest diet with anyone who will listen. Men, on the other hand, aren't really very comfortable sharing diet tips. Actually, in this case, the men are probably instinctively doing the right thing.

The last thing any man should do is announce he's on a particular diet or trying to lose weight. Aside from the fact that announcing you're on a diet is virtually the same thing

as telling everyone that you haven't been taking care of yourself, have no willpower, and are FAT (none of which are particularly attractive traits), once you make your diet public you open yourself to the constant—often unwelcome—advice, interest, and curiosity of the people around you. "How's that diet coming? Lost any weight?" These are not questions any man really wants to answer all the time, particularly when, as inevitably happens, he's hit a weight plateau and feels stuck or has an overwhelming need for a jelly pastry.

Also, although some people can be very supportive to you when you're dieting, you really can't depend on your friends for help. Nor, if you're sitting at dinner with your family is it going to be easy to avoid the rich foods others are eating. It's equally difficult to avoid the temptations of fancy dishes at a restaurant, particularly when friends are saying, "Oh go on . . . it won't hurt you just this once." In reality, it won't hurt someone who's in good shape to pig out once in a while, and actually, even the out-of-shape man who's taking charge of his physique most likely won't be destroyed by

an occasional binge. But the key words here are "once in a while" and "occasionally." And herein lies the problem.

It's just one of those things. After a night of eating all the wrong foods, and stuffing yourself with junk, chances are the next day you have a "hunger" for fattening and unhealthful foods. And you figure that once more won't hurt you, then once again after that . . . until you wake up one morning carting around several excess pounds. That weight seems to actually creep up on you from out of nowhere. Well, in reality it isn't coming from nowhere, it's coming from your own self-indulgence or perhaps just lack of attention to what you're doing.

If a man is overweight and doesn't pay any attention to what he's eating, moving (at most) from the office to home in front of the television, he's clearly laying the groundwork for being fat. The cycle feeds (excuse the pun) on itself.

The opposite is also true. The more a man exercises, watches what he eats, cares for his body, the more his body wants, *he wants,* to do these things. If, in fact, you are overweight due to excess eating and not suffering from any genetic or physiological condition that causes you to be big, then it's time to think about getting rid of the bulk. The problem is, just how are you going to do it?

If you are one of those people who respond to outside discipline, then perhaps a commercial diet plan will work for you. But if you don't like the idea of being told what you can eat and when you can eat it, or simply can't function on a diet plan that includes weighing, measuring, or preparing elaborate meals, taking food out of boxes (and isn't that an impressive thing to do at a corporate lunch with the boss?), mixing powder with water, fixing your own prescribed dinner when your family has sent out for pizza, or asking the waiter at a restaurant about the composition of each dish, then most likely you're not going to stick with the program. And even if you do, there's a

hefty problem looming in your future. It is becoming increasingly obvious that although you can lose weight with commercial diets, the chances are that you'll put the weight back on soon after the effort is over. In fact, there are some authorities who suggest that people who have lost weight without being in control of their own eating actually add additional pounds later on. Nice, huh?

Of course, once you've gotten fat again, you're prime to try another diet. And if there's one thing there's plenty of, it's diets. You can find an apparently endless supply of diet books, diet plans in magazines, newest diet discoveries . . . all promising to teach you to control your weight. Well, the one thing they should teach you is that they wouldn't all be necessary (that is if any of them are) or so popular if any of them worked for everyone. The fact is, they don't.

Once again, it's all about you as an individual. You have to take the time to learn about your own body and discover what does and what doesn't make you fat, and what you can and can't live with when it comes to losing weight.

It may not sound very scientific, but a lot of guys have been able to control their weight simply by learning what makes them fat. Now, this isn't as dumb as it sounds, simply because

different bodies respond differently to virtually every food. Of course, the intelligent man avoids fats and limits sugar and salt. But there's more to it than that. You're no doubt well aware that there are some foods you don't like, others that make you sick, and many that you really love. It stands to reason that there are, equally, foods that cause you to eat more, and/or contribute to weight gain. And you also know that on certain days you can eat more than you can on others without any noticeable effect. It all depends on your particular physical cycle, your own digestive system, and your own individual body chemistry.

For example, one model who decided to drop a couple of pounds used his workout partner's diet consisting of no fat, fruit during the day, and a big meal at night. Everything was fine, except that the fruit, being a natural sugar, made him uncomfortable. He substituted vegetables and felt fine. Another man might find that certain carbohydrates trigger a lust to eat more and more, yet another may get this same reaction from heavy proteins such as steak.

If you have regular business lunches or go out for dinner much of the time, counting anything—calories, carbohydrates, or fats—can be very difficult. But you can avoid the foods that you know make you eat more, add weight to your body, and cause you to feel lethargic or heavy.

Your body will tell you. Food is supposed to give you energy and fuel. If after a big lunch you're tired and completely out of energy, then you've eaten the wrong things. If you eat something and instead of making you feel full, it makes you want to eat more, than you've chosen the wrong food. It's all very simple. You just have to take the time to learn about your own body. And if you're willing to study and read the diet manuals, you should certainly be able to squeeze in the time necessary to make a list of your own dangerous foods. It stands to reason that if you lose weight from a diet you yourself design to work with and for your own body, you'll be able to stay with it and keep your weight where you want it forever.

Make your own diet, keeping common sense and health in mind, and always remembering that you're eating in order to do other things.

It must be noted that regardless of what eating plan you choose, it has long been established that it is virtually impossible to lose weight without exercising. The two work hand in hand: Exercise burns calories, while at the same time lowering your emotional and physical need for food.

A Word About Being Fat For some men, losing excess weight seems out of the question. They have been, are now, and most likely always will be, heavy. Now, in reality, unless your weight problem is due to a physical condition, chances are you simply need to either take control of your eating and exercise habits or perhaps get some kind of medical help to get you into shape. But even if everything has failed and you're still carting around excess poundage, don't make the mistake of thinking

you can't have style and elegance. A man who is heavy and doesn't take care of himself, dresses sloppily, and looks messy and unkempt is usually referred to as a "fat slob." An almost identical man, in the same physical condition, who makes an effort to look his best, is most often referred to as "big."

The point is simply that *every* man has some kind of individual physical peculiarity. He might be very short or tall, have a big butt . . . whatever. Don't assume that looking good is only for the "perfect people." It's just that each man has to keep his personal limitations in mind when he's getting it together. For a big man, as for every man, presentation is vital. The heavy man must make sure his clothes fit properly and are kept in good shape; his skin and hair have to be perfectly groomed. In other words, the heavy man just has to make sure that his weight is not the first thing people see. Rather, people will just notice a good-looking man who happens to be "big."

Simple Solutions

■ **Body-conscious athletes have been moving toward a dairy-free diet. This is due to the theory that suggests that, although these products in themselves may not be fattening, they stay in the body longer than grains, vegetables, and fruits, thus holding other foods in the body and contributing to weight gain. At one time dairy products were considered one of the four major food groups; however, today the Federal Government dietary guidelines have dropped dairy products from their list of nutritional requirements.**

■ **Another interesting eating theory is that less is definitely more. If you're under a heavy work schedule and need to be particularly mentally sharp, eating less will actually help you keep on your toes. The concept is simply that if less food is taken in, the body's machinery isn't busy digesting and can respond easier to other demands. (See exercise section page 12.)**

■ **Cutting your caloric intake by ten percent is** said to increase longevity. The average man needs twelve to fifteen calories per pound of body weight each day to maintain his current weight. Cutting this down ten percent is reported to add years to an individual's life.

A Word About Water Water, one of the cheapest, easiest-to-get commodities, is one of the best things for your body. It helps fill you up so you're not hungry, and it flushes out the body, keeping it cleaner and healthier. Drinking a lot of water helps maintain a good complexion and gives you energy.

There is even water therapy, actually a water workout. For two weeks, complete tough exercise sessions, eat regularly, and constantly drink water—and not just the normally proscribed eight glasses a day. This routine requires really heavy water drinking; you're virtually never without a bottle of water in your hands, drinking regularly. The combination of the good workouts and water will, according to some exercise authorities, in the two-week period actually realign the body's appearance, causing it to slim down, even creating muscle definition. This program is a very simple method of making sure you look your best before leaving for a vacation or just getting a healthy pickup during a stressful period.

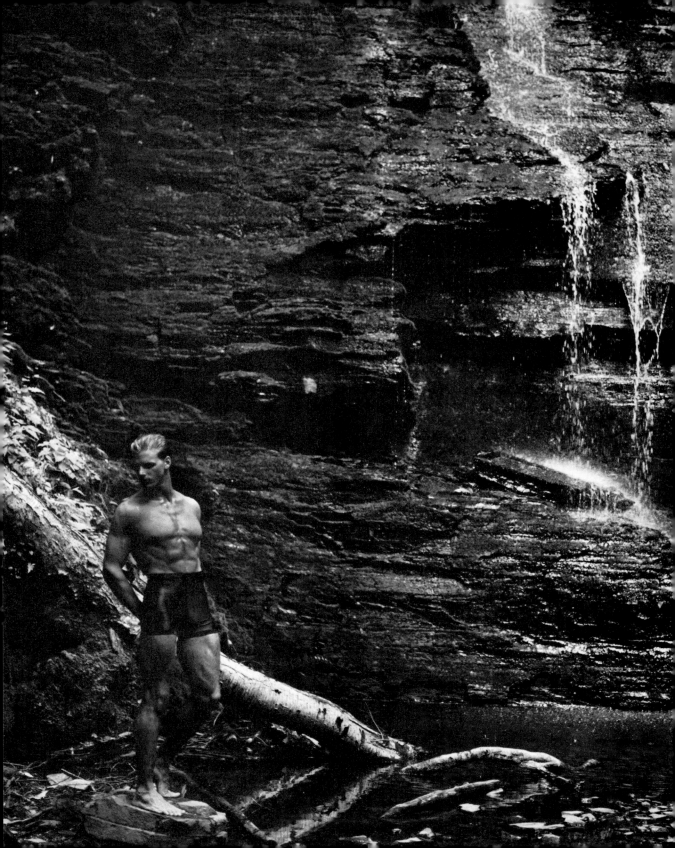

Chapter 4

Body Care

Having spent time working out and eating correctly, you might think you have body care under control. But there are some final touches that separate the well-groomed man from the average guy. Not taking care of your skin is like investing in an expensive suit and then pairing it with dirty shoes. It just doesn't make sense to work out regularly and eat properly, then ignore some basic good-grooming techniques.

The bottom line here is being clean. Now this is perhaps one of those things that most men think hardly needs to be discussed. But it is amazing how easy it is to simply forget that the skin, in order to be at its best, has to be thoroughly cleansed (see Part II, The Face).

First thing in the morning, after working out, immediately on reaching home from work (unless you stop at the gym) get in the shower.

Never under any circumstances leave the gym without showering. It doesn't matter how

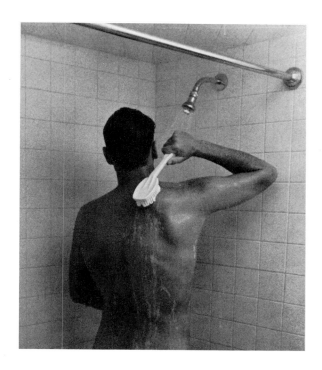

nature it should be mentioned that wives and lovers have been known to remark that one reason they aren't in the mood for romance at bedtime (other than having dealt with several children, done a full day's work, fixed dinner, and cleaned the house, naturally) is that their husbands and boyfriends come to bed still reeking of the day. If you've been on your feet working for eight or nine hours and then drop your clothes and climb into bed expecting a good time, you might as well ask your other half to cuddle up to a dust bin. Dirt is not romantic, sexy, or even tolerable. In addition to taking care of your skin, showering at night after work might help you get lucky.

So, just keep it clean. Now, what you're going to shower with is not really something that needs to be discussed. Let's face it, you're going to use soap, probably whatever brand is on sale. All right. Of course, you're better off using a natural soap, one that has skin-protective ingredients. And for any kind of special skin-care needs, chances are you'll be able to find the right product. But in reality, normal skin just essentially needs to be kept clean.

busy or how late you are, take a quick shower. The bacteria you sweat out and into your gym clothes is transferred back onto your body. Not getting rid of it is a clear invitation for acne, blackheads, clogged pores, rough skin, oily skin . . . all kinds of problems.

And there's another reason for all this showering. Although of a somewhat delicate

However, if you have very dry skin, you

might want to try an olive-oil-based or a super-fatted soap that may help to condition it. Body oil helps as well.

A lot of men don't want to be bothered with body oils because of the mess. But they can certainly help dry skin feel and look a lot better. And to avoid glooping up your shower, keep your oil (any kind is all right provided it doesn't contain mineral oil) at the gym. When you're showering, apply the stuff liberally and rinse it off. It will leave your skin feeling nice and smooth. It may be a little hard on the people who have to clean up the locker room showers, but, hey . . . if you rinse out the shower well, it won't be too bad.

If oily skin is your problem, then cleansing the skin well is vital. While excessively oily skin resulting in extreme body acne may re-quire treatment from a dermatologist, simple oily skin can be personally treated with regular cleansing using a clay soap. You might also use a loofah in the shower to remove the external evidence of oily skin.

After your shower, it's important to dry thoroughly. All right, this may sound like child's play. After all, you know how to use a towel. But in fact many men just don't get their skin completely dry which can lead to uncomfortable skin reactions and general messiness.

And you should know how to dry your skin according to your skin type. If you have dry skin and have used a moisturizing oil in the shower, pat yourself dry with a soft towel. Patting doesn't rub off the thin veneer of oil that you just put on. This process also helps protect dry skin from being chafed or irritated.

Donald Charles Richardson

If you have oily skin, dry briskly with a rough towel (sauna towels are available at specialty shops) which will help retard the oil buildup. Make sure the towel is dry.

Using a talcum powder is a personal choice to be made at your discretion. Using deodorant isn't. There can't be more than a couple of men in the world who don't sweat under their arms. Even if you don't sweat a lot, use a little deodorant just to be sure you're all right. And remember that *deodorants do not work on wet skin.* If you apply a deodorant to wet underarms you're asking the product to work immediately. It is most likely designed to keep you dry (or at least odor free), not get you into that condition in the first place. Dry underarms thoroughly before applying deodorant.

Take note of the fact that really smelly deodorants can be almost as offensive as body odor. Keep it quiet and calm. In fact, you're better off using an unscented product, particularly if you add after-shave or cologne (see page 48).

If you suffer from particular problem areas, such as feet and crotch, that tend to sweat heavily, spray powders can be helpful. However, avoid using spray deodorants in the crotch area; they can be very painful.

Taking care of the body's skin isn't a big deal. It's just a matter of getting a routine established and sticking with it. Just because the skin doesn't show all that often is no reason to ignore it. After all, some of your best moments might come when you're out of your clothes.

Simple Solutions

■ At the gym, if you feel chilled after showering, dry the back of your neck first. Getting the moisture off this area will help the rest of the body warm up quickly.

Industrial-Strength Endeavors

■ One method of helping to control oily body skin is by pouring hydrogen peroxide over the affected area. Some men have been known to actually apply pure grain alcohol to oily skin, but this can be very damaging and uncomfortable. However, hydrogen peroxide, used once a week or so (depending on the severity of the condition) can be useful in keeping the appearance of oily skin at a minimum. You should not use any drying product on skin that is suntanned or burned, and if the condition is excessive, treatment from a doctor may be required.

A Word About Feet No man of style can properly present himself if he has aching feet, so every once in a while give yourself a "feet treat."

Begin by soaking the feet in any footbath preparation mixed with warm water. Dry the feet thoroughly, and use a pumice stone to rub off the rough areas. Soak again for a few minutes. Dry again, trim the nails, and then apply lotion or powder. This whole procedure takes, at most, fifteen minutes. And you'll feel a lot better all over.

Also, you can care for your feet by changing shoes every day. Once you're home from work, remove your shoes and let them dry for a day before wearing them again. (It's better for the shoes, too.)

Socks naturally have to be changed every day. Gym socks, certainly, should only be worn once, then washed. You sweat more at

the gym than anywhere else, so keeping your gym socks clean will help your feet stay healthy.

Foot odor is a preposterous condition. Clean, healthy feet don't smell (unless they're afflicted with some unusual condition). Men whose feet smell need to employ better preventive techniques. Wash the feet more often, use foot deodorants, change socks as many times as necessary, use charcoal liners in your shoes, get prescription medications from your doctor . . . do whatever you have to do.

Sometimes men find that their feet feel tired and stressed out from the burdens placed upon them. A few simple foot exercises can help relieve the situation.

Actually, one of the best things for your feet is a barefoot walk on the beach. Strolling along on sand cleans and scruffs the feet while the "give and take" of the sand itself actually relaxes them and strengthens the arches.

If you can't get to the beach, then simply sit comfortably and "work your feet."

Start by stretching your foot, expanding the toes, then curling them into a tight ball. Stretch them again.

Picking up a pencil with your toes is a good exercise, and if you can manage this exercise easily it indicates that you have good foot flexibility. Stretch, flex, and contract your toes every once in a while in the office. You'll find you get around a lot better on your feet.

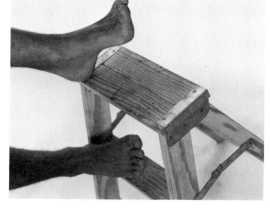

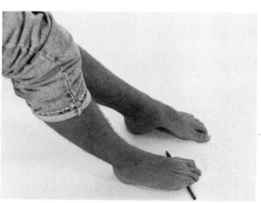

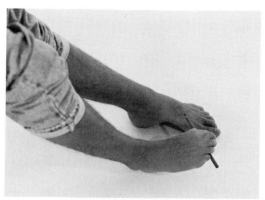

EASY MANICURE

There's an old saying that the hallmark of a true gentleman is well-trimmed nails and well-polished shoes. Actually, there's more to it than that, but just like any other part of your personal presentation, keeping your fingernails in good shape is very important. Few things are more off-putting to a friend or co-worker than watching you—well dressed, in good shape, spiffy—reach up and adjust your tie, displaying broken, bitten, or even, in some cases, dirty nails.

When it comes to taking care of your hands, the most important things include neat nail trimming, removal of ragged cuticles, and absolutely no nail biting.

You can trim your nails most easily using nail clippers. Most men prefer these handy tools because they're easy to manipulate and don't require a lot of time and concentration. It should be pointed out, however, that the nails will often "lean" toward the area from which you're trimming unless you turn your hand toward your body, making an even, contoured line around the nail.

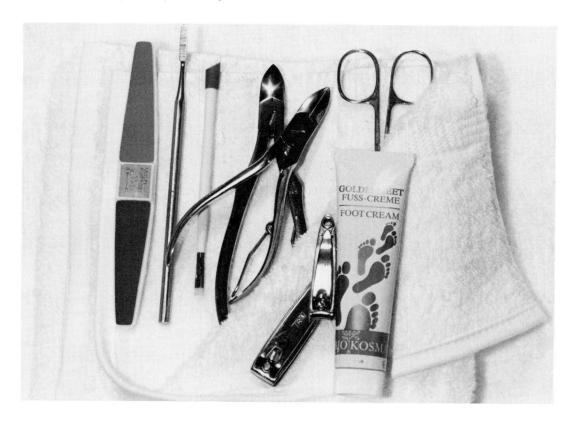

As for cuticles, you should push them back against the skin whenever they start to encroach onto the nail. Cuticles can be held at bay with moisturizer. Applied around the nail, it will retard the formation of a cuticle and make it easier to push the cuticle back against the finger out of sight.

What can anyone say about nail biting? It's gross. So take whatever measures you have to to stop it. There are preparations available which, when put on the nails, make them taste terrible and thus less appetizing. If necessary, consult with your physician. Just don't do it.

Hand creams can be effective if you have dry skin. But keep in mind that these products will wash off each time you wash your hands. Also, few men like the idea of greasy hands at work, so it might be a good idea to use them only at night.

Neither models nor any other man of style would ever think of using clear nail polish or even buffing their nails since it can make them appear unnatural. Simple fingernail care means clean, well-trimmed nails without cuticles. Maintaining good-looking hands is not just a nice grooming touch, it is a necessity for any man in business.

Simple Solutions

■ **If you have particularly dry skin, you might want to take an oil bath occasionally. Just add a few drops of any natural oil such as corn, safflower, or olive oil right out of the kitchen to warm bath water. Mix it around and then settle back and relax. Stay in the tub at least fifteen minutes so the heat from the water can open your pores and the oil can attach itself to your skin. Be careful getting out of the tub.**

Industrial-Strength Endeavors

■ **At the gym after your workout, rub your body down thoroughly with oil in the shower. Leave the oil in place and walk (carefully) to the sauna or steam room. Sit quietly for a few minutes. Return to the shower and rinse off the excess oil (there won't be much left). This procedure is more time-consuming than simply rubbing oil on the body while showering. But it is also more effective in combating dry skin.**

PART II

The Face

Anytime either male or female models appear on talk shows or give interviews, the question of what they do for their skin and hair is inevitable. So is the answer. "Nothing," is the standard reply, "just wash and go." This response accomplishes two things: First of all it helps the models avoid the stereotypical label of being self-absorbed with their looks; and second, it makes them appear to be more regular people.

However, an unfortunate side effect of this "average guy" attitude on the part of the models is to enforce the impression that there's nothing the real average man listening to this dialogue can do to help himself look as good as the models.

Truthfully, the amount of time a model spends working on his facial skin depends on the model and the skin. Each does what's necessary to keep himself looking his best. Admittedly, a few (especially the younger ones) don't worry much about skin care. But then, few young men in any profession are concerned about their skin care. After all, they have youth on their side. And unless they're particularly afflicted with oily skin, acne, flaking dry skin, or some other obvious and unpleasant condition, they probably do, in fact, "just wash and go."

However, the intelligent man doesn't wait for the damage to be done before taking some defensive action when it comes to any aspect of his personal appearance.

Just as it's harder to get back in good physical shape after several years of neglect than it is to keep the body toned and fit in the first place, it is simpler to maintain healthy skin than it is to have to suddenly start fighting complexion problems and the signs of age.

Chapter 5

About Skin Care

The bottom line when it comes to skin care is the same as it is when it comes to any other personal care program. You need what your particular face requires; the degree to which you have to work to look your best depends on what you have to work with.

There is one problem. Although for even the most macho man the concepts of exercise and diet (whether they pay any attention to them or not) are understandable and acceptable, skin care remains something of a mystery, and for some guys still bears the stigma of "sissy." However, for any man who truly cares about the way he looks and the way others both professionally and socially respond to him, it's time to get over the hang-ups and look at skin care as simply another part of an intelligent grooming practice. And if you don't believe this, the following points should convince you:

• Age. A male model can continue working as long as he looks good. "Good" being the op-erative word. Even if a manufacturer chooses to use a mature image to sell his product, it doesn't mean the company wants someone who looks old and tired. And in order for the mature model to withstand the unrelenting and all-seeing eye of the camera, he has to pay attention to the condition of his skin.

By the same token, it makes life a lot easier on the job for any man if he doesn't look like the old guy in his office. A good skin-care rou-tine is the easiest way to keep the face looking youthful and fit. In point of fact, a man who keeps his skin and body in good shape just doesn't look old, regardless of what his actual age is.

• Environmental and business hazards. The daily grind of work, travel, stress, and envi-ronmental conditions exist in virtually every kind of job. It doesn't matter if you're a model or work on a construction site, in an office building, or in a retail outlet, your skin is *out*

there all the time, constantly battered by tough and often unpleasant conditions. If you want to keep your skin in good shape, you have to fight back against the elements.

• Competition. Just as the competition for any high-paying modeling job is very tough, the best jobs in any field attract a vast collec-

tion of applicants, many of whom have almost identical credentials. Obviously, when it comes down to the final selections, the guy who makes the best appearance is going to have an edge.

• Availability of products. Just a casual walk through any major department store reveals

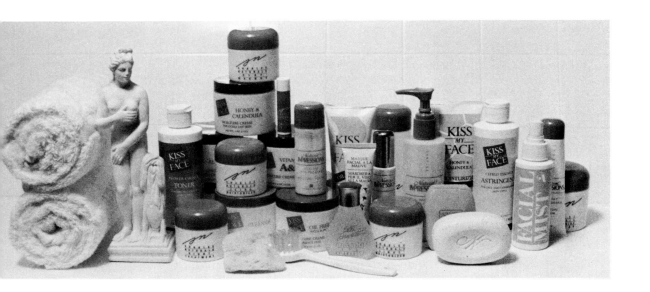

counters spilling over with the latest surefire preparations guaranteed to save any man's skin. Some are good, others all right, many terrible. The men's market is not nearly as large as the women's (which appears to be totally out of hand) but nonetheless, skin-care companies have recognized that there's money out there in men's preparations, and they're bound and determined to get their share.

There is some good news to all this over-abundance, though. First, the presence of these products cause men to think about their skin; second, the constant selling of men's skin-care products gets men used to the idea of skin care and removes some of the embarrassment; and third, there's just more to choose from (which can also be a minus, but more about that later). The point is, the procedures and products you need to take care of your skin are available. You just need to know what to use and how to use it.

Chapter 6

The Basics of Skin Care

The first and most important aspect of good skin care today, as it has always been and most likely always will be, is keeping the skin clean. In fact, an ongoing concern with clean skin is virtually an obsession with top male models. (Again they're in the lead. The brutal fact is that virtually every man living and working in an urban environment most likely has deep grime embedded in his skin that causes him to look tired, unhealthy, and even older than he is.)

At this point you're probably thinking, "Great, I'll wash my face more often and that'll take care of everything." Nice idea, but unfortunately there's more to it than that.

Most people think of skin-care products as "wrinkle creams," designed to retard lines and the other signs of aging. Now, let's get rid of that nonsense. No commercial cream, lo-

tion, or emollient, even one with mysterious ingredients, is going to dissipate wrinkles. And, in point of fact, there's actually nothing wrong with a man having a few character lines in his face . . . provided the skin they're in looks good. But lines and wrinkles in dull, gray skin are disastrous. Think of your face, if you will, as a work of art. No superb creation is harmed by a few bumps and bruises, so long as it's shined and polished well. So don't panic about lines . . . just take care of the skin itself. And this process isn't nearly as difficult as some people would make you think.

In reality, the basics of skin care boil down to three steps: cleaning, toning, and moisturizing.

There are, naturally, variations in these simple steps. To find the best ways of taking care of your individual skin, go through the follow-

ing procedures, choosing the methods and means that best suit your particular needs. Don't bother with anything that isn't suitable for your skin.

MORNING ROUTINE

Good skin care begins in the morning with careful cleansing, shaving, toning, and moisturizing. Skin-care product manufacturers maintain that you need specific cleansers based on your skin type. This is true. There are cleansers for men with oily, dry, or normal skin and they can be very helpful. But let's face facts; just as you do when taking a shower, most of you are going to use soap. It's simple, it's easy, you can wash your whole body with it, and it doesn't require any special shopping. All right. Soap will do. But at least buy a soap that won't hurt your skin. For example, if you have dry skin, buy super-fatted soaps; oily skin, use glycerine soaps. You can use these on the whole body and they're kinder to your skin than generic soaps.

Regardless of what you choose to wash your face with—soap, cleanser, lotion—the one product most men never think about, and is actually both helpful and comforting, is a face brush. These small, inexpensive tools with very soft bristles are super for getting the dirt off the skin. They are also invaluable for a close blade shave (the method still preferred by most men) because the bristles can reach between the hairs of the beard and really get the whiskers wet. Men with oily skin will find that face brushes, provided they're kept very clean, can be very helpful in controlling the condition.

The basis of getting a good blade shave is moisturizing. There are commercial products which are designed to soften the beard and make the hairs more receptive to shave cream. It is not, however, necessary to invest in these products unless you find one that you swear by. A little regular moisturizer or even a very

small amount of vegetable oil right from the kitchen can work as well.

The method you choose to set up your beard dictates when you wash your face in the shower.

If you choose to use oil, wash your face first, apply the tiny amount of oil, rub it into your beard, continue with your shower, and right before you turn off the water, once more put your face under the spray and soak your beard. If you are careful not to actually wash off the oil, a small amount of it will stay in place while you shower, grasping moisture and holding it, causing the beard hairs to soften. The final rinse blasts water into the oil, preparing your beard for the shaving product.

If you use a special preshave product or moisturizer, wash your face last and apply the product right before you step out of the shower. Obviously, creams and lotions will rinse off more easily than oil; however, they do soak into the beard more quickly. So, by waiting until the end of your shower to wash your face and apply the product, you've given your pores a chance to open, the washing removes dirt and debris, and wets your beard. Applying the moisturizer to the wet hairs traps the water in place.

Out of the shower, before even starting to dry the body (you can do this in the shower after you've turned off the water if you don't want to get the floor wet), apply shaving cream.

There are dozens of shaving creams, foams, and lotions on the market. The basic rule of thumb is that if a man has very dry skin, he's best off using one of the creams or lotions which have an oil base. If his skin is oily, he's most likely better off with a traditional shaving cream, provided he chooses one that includes silicone, which forms a thin, protective film over the skin. To work properly, shaving foams must be left in place for at least a minute and a half so they can soak into the beard. Shave creams and lotions usually work faster.

Dry the body while your shave cream sets

Donald Charles Richardson

and soaks. Rinse your razor under the hottest water possible, turning it back and forth under the faucet. Shave beginning with the cheeks, then under your lower lip, finishing up with the chin and upper lip. (The hair in these two areas being heavier on most men; allowing them a little extra time to soak is beneficial.)

The shaving ritual is finished by rinsing the face *twenty* times in warm water to make sure all traces of shave cream and shaving debris are removed. This final step is very important. In order to look its best, a face must be completely clean after shaving even if it means getting back into the shower for a final rinse.

If you're really into the whole thing and have some extra time, you might combine hair conditioning and face rinsing. Before leaving the shower, put hair conditioner on and leave it in place while shaving. After shaving get back into the shower and rinse out the hair

and clean up the face. Rinsing your face in the shower after shaving can actually help eliminate razor discomfort and noticeable shaving marks. The force of the shower effectively soothes the skin.

One of the standard complaints from many men is that, regardless of how careful they are, they just don't get a smooth, clean shave. The answer should be obvious. Do it again. By the time you've finished your first shave your face should be very wet; consequently, the second shave should be considerably easier to accomplish.

Every skin-care specialist warns against shaving against the hair growth, cautioning that this can result in irritation. However, it's *your* face. If the smooth results that come from shaving against the hair are worth the risk and you take adequate precautions (proper degree of wetness, moisturizer, letting the shaving

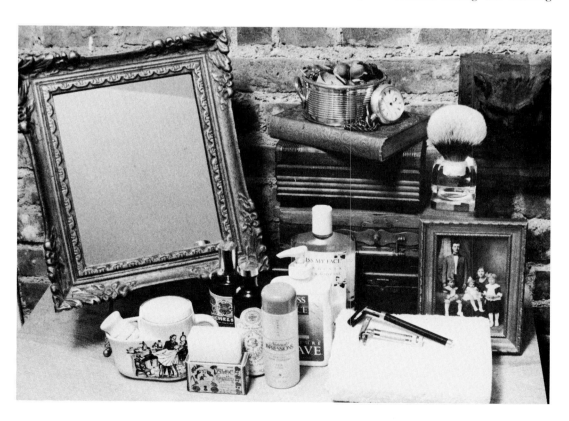

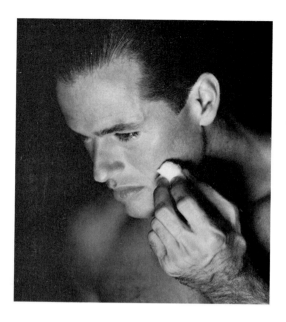

Toner is applied to the face for two reasons: First, it cleans off the debris left from shaving, like tiny hairs and flaking skin; and second, a toner closes the pores. Obviously, splashing isn't the best way of doing either of these things.

To properly use a toner (even if you still insist on an after-shave), just put some of the product on a cotton ball and wipe it over your face. This method will also help cut down the amount of stuff you use, thus saving you money and avoiding the problem of coming out of the bathroom smelling like you spent the night in some particularly smelly boudoir. Never, *never* wear a scented cologne on top of a scented after-shave, even if they're the same scent. Historically, the only people who did this kind of thing were members of the French court during the reign of Louis XIV who rarely bathed, and doused themselves in perfume to cover the resulting body odors. It is hoped that no one today continues this practice.

product stay in place the required amount of time), then go ahead and try it.

Despite the fact that some men still prefer the tingle that results from alcohol-based after-shave products, more and more are realizing that their faces need to be comforted after shaving, not shocked. And the old idea of splashing on some after-shave is, despite the fact that the action may be invigorating, really not very productive.

Actually, it should be noted that very few professional men of style use heavy, penetrating after-shaves because the fragrance just gets to be too much. You can buy scent-free, alcohol-free toners (excellent for the skin) or if you're on a budget or trying to clear up problem skin, use witch hazel or even hydrogen peroxide for their anti-infection properties.

Chances are you normally wash your face, shave, and use after-shave in the morning. You may not, however, finish the process with a moisturizer. Either you don't want to be bothered, don't understand what they do, never think of it, or just aren't interested. And in reality, this is one of those things that it's actually easier to go without. However, if you truly care about your skin, you have to bite the bullet and use a moisturizer. Unless you have particularly oily skin or a dermatological problem, a moisturizer is almost a necessity these days. The ozone layer has diminished, and the air is dryer, even in controlled-temperature offices. Most men can tell that the air is dry because they feel it in their throats and sinuses.

And obviously if your throat, protected as it is inside your body, feels dry, you can imagine what the atmosphere is doing to your skin.

To begin with, moisturizers don't have any secret or mysterious qualities. They simply act to trap and hold moisture on the skin. The problem with them, aside from most men's apparently inherent dislike of the idea, is that the same properties that cause them to help keep the skin fresh, thus making it look smoother and healthier, also creates a Velcro-like surface against which dirt is attracted and held. Again, it's all a cycle. You clean your skin and moisturize it to look better, which results in a greater accumulation of grime, which means cleaning your skin again, which can result in drying which requires moisture to restore it to its best appearance. Sounds silly doesn't it?

But it's still necessary. It's better to have the dirt and grime accumulate on the moisturizer than directly on your skin, and the moisturizers do, in fact, help keep your skin looking its best.

The best way to apply any moisturizing product is to put it on damp—not wet—skin. After toning the face, spray or splash a little water onto your face and then put on your moisturizer.

The only men who may be able to avoid using moisturizers are those with very oily skin. But even if you do have this condition, it's possible that certain areas of the face can still be dry and it's a good idea to put a *little* moisturizer around the eyes, maybe on the forehead . . . it all depends on your individual skin pattern.

As to which moisturizer you choose, well, that's pretty much up to you . . . except for one thing. Avoid mineral oil. This is one of those situations where for safety you're better off erring on the side of total avoidance. Mineral oil has to be one of the cheapest substances available for use in cosmetics of all kinds. But there has been considerable research to show that it can actually combine with the body's natural oils, drawing them out, and thus increasing the opportunity for dryness to occur.

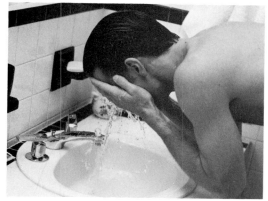

It could be a vicious circle. The mineral oil product makes the skin feel smooth, but it also helps to dry out the skin, thus requiring more of the product to make the skin feel smooth . . . and on and on.

Now, in fairness, some cosmetic authorities maintain that there are various levels of mineral oil, some good, some not. Naturally, anyone using mineral oil in their products is going to maintain that the type of mineral oil they use is of the highest caliber. However, since packaging laws only require that the manufacturer list the presence of the ingredients in its products and not the quality of those ingredients, you're better off simply finding a product that doesn't contain any mineral oil.

By the same token, it doesn't make sense to invest huge amounts of money in any preparation. Some of the best moisturizers are very inexpensive, made from natural ingredients,

and as helpful as the highest-priced products. Since different products react differently on each individual's epidermis, it is important to choose a preparation whose ingredients are compatible with the condition of your skin. But that doesn't mean it has to cost a fortune. If you find one that seems to work for you, even if it comes in a bulk bottle and sells for a buck, use it on whatever part of your body feels dry. There is no law that says that you have to have different preparations for the face and body. If you find one that works everywhere, go for it.

During the day, most men won't be interested in doing anything for their skin. After all, you're working, busy, and not interested in any skin-care treatment. Fine. Then don't do anything for your skin. The point is to avoid doing anything that harms your skin. If you work in a heated, dry office, get a humidifier. If this is too much trouble, at least place a bowl of water on the radiator. The moisture either of these put into the air will make your sinuses and your skin feel better.

When in serious thought or under stress, don't rub your face with your hands. It stretches the skin and brings dirt and germs from your hands onto your face.

And here's one you may or may not approve of. If possible, during the day, don't wash your face with soap. Brush your teeth after lunch, wash your hands as often as you like, dust off your shoes, splash your face with water, but don't *wash* your face. It'll remove what's left of the moisturizer, open the pores to environmental dirt, and encourage dryness. Unless you're willing to carry around toner, moisturizer, and a clean towel, don't wash your face unless absolutely necessary.

Once back at home after the day's work, go directly to the shower. You don't have to spend a lot of time scrubbing, just a few moments to get rid of the day's collection of grime. Too often, men get home after a hard day's work, kick off their shoes, pull down their tie, have dinner, and collapse in front of the television. This is the easiest way of encouraging bad skin, simply because built-up dirt and debris left on overnight becomes a breeding ground for bacteria and more skin problems. You don't have to use a toner or moisturizer (although they're a good idea) at night. Just let the skin breathe if you want. Provided it's clean.

See? It's all not nearly as hard as you thought it was. What it boils down to is not, for the most part, doing new things but doing the same old things correctly.

A Word About Facial Hair Over time, facial hair has gone in and out of fashion. During some periods, virtually every man sported some kind of beard or moustache. Then there were long periods during which the sight of any kind of facial hair would have been shocking. Moustaches have been used theatrically to denote villainous characters; beards have been a part of political protest. Now, for the most part, men can set aside all the various social and economic purposes facial hair has been chosen to exemplify and concentrate on what is truly important: Does it or doesn't it work?

It is possible to make some dramatic alterations in a face by growing a beard or moustache. Heavy cheeks can be slimmed, frail facial features can be given strength, weak chins and small upper lips can be covered, maturity can be camouflaged, youth can be given distinction.

But—and it's a big but—the facial hair must be grown and shaped to fit a man's individual facial features. And it has to be kept well-groomed and neatly trimmed.

Here are the basics of beards and moustaches:

The length of time it takes for the hair to grow naturally varies from person to person. However, chances are your best route for growing facial hair is to do the initial growing during a vacation away from work; otherwise you'll look scruffy at the office and most likely get adverse comments.

Don't try to style facial hair until it has had a chance to fill in.

Expect the hair on your face to be of a slightly (or even dramatically) different color from that on your head. Rarely do men have completely matched hair. If facial hair grows in a color that appears too unusual (for example, bright red against brown hair on the head), then you might want to consider coloring one or the other.

Unless you belong to a particular religious organization that has a prescribed beard style, beards should always be accompanied by a moustache.

To grow the right beard and moustache for your individual face, take careful note of your facial features. Although not writ in stone, the following points should be checked out before you start sprouting your facial fur:

• The shape of your nose. Men with large noses should most likely have large moustaches which will balance the nose. By the same token, a little nose sitting above a huge moustache looks silly.

• The shape of your face. If you have a thin face, you can grow a full, short beard and moustache (as a long beard and dropping moustache will just make the face look longer). Conversely, a full face can wear a long beard and moustache. Since beards are excellent for covering weak chins, a great many men opt for this facial camouflage. However, it is important that the beard be grown from ear to ear, otherwise the presence of facial hair just on the chin will only pinpoint the weak chin.

• The amount and cut of your hair. Bald men can have beards and moustaches, but they must be controlled. Huge beards combined with the absence of hair on the head look strangely suspect. Men with short, carefully controlled hair should have equally short, well-trimmed beards. Men with long, flowing hair can have larger beards and moustaches.

If you have difficulty deciding what kind of beard you should have, check with your hair-stylist and get his/her opinion. Just remember, a beard should be a beard, and not look too contrived or funny.

Just because you don't shave your whole face anymore once you have a beard doesn't mean you can ignore your skin. In fact, there's a good chance that maintaining a beard and moustache will take longer than shaving every morning.

To begin with, once you have established the shape of your beard and moustache you must shave the areas you're not letting grow daily to keep the beard form looking neat. To keep a beard clean, use a gentle shampoo, not soap, every day. And you can even apply hair conditioner to maintain the soft texture of the hair. (Facial hair can be considerably more coarse than hair on your head, so conditioning regularly is very important.)

Conditioning the skin beneath a beard is also important. If your skin feels uncomfortable, dry, or excessively oily, use the proper measures to treat your skin.

Brush your beard regularly in the direction you want it to lie. Trim it at least once a week. The easiest way of trimming a beard is to comb through the hair, lifting it up and cutting across the comb with a scissors or electric razor.

Beards and moustaches can be a nice touch, adding distinction and élan to your face. However, they must fit in with the rest of your lifestyle, adding to, not distracting from, your professional image.

Simple Solutions

▪ On days when he's doing a special shooting, a model might use an ice cube to tighten his skin and give it a glow, although none of the guys do this every day since it can damage the capillaries. However, if you have to look your best and have had a rough night, running an ice cube over your cheeks and around the eye area might brighten you up.

▪ If your skin looks lifeless, using a scrub oc-

casionally will help liven it up. Scrubs should be used once, at most twice, a week. Never use a lot of pressure when you rub them over the skin. And never use a scrub on tanned skin (not that you should need it, but some men won't leave well enough alone) since the skin is already damaged in order to be tanned and the grains in these lotions can actually scar the skin.

■ Quick fixes in case of a sudden unexpected pimple or skin eruption include rubbing a piece of citrus fruit on the area, putting deodorant on a finger and lightly applying it to the pimple, or using clay masks to dry out the area. If a pimple appears and there isn't time for any cures to work, using an erase stick right on the top of it (not on the whole pimple or any of the surrounding skin) will virtually make it disappear. Too often, men who want to cover a blemish will think it's necessary to cover the blemish entirely and then blend the cosmetic around the area. This usually only draws attention to the problem, whereas simply touching the top of the blemish (where it is usually red or particularly noticeable) will effectively cause it to blend into the rest of the face.

■ Carry a water spritzer. If you're working hard and need to look fresh, you should have a bottle of water and a small water spritzer handy at all times. Keep drinking the water and occa-sionally spritz your face. You'll feel refreshed and invigorated. And the water will plump up the skin, making it look healthier and fresher.

Industrial-Strength Endeavors

■ Both models and businessmen are getting more and more interested in the professional facial. The important thing to remember about these treatments is not to go into them expecting miracles. The signs outside the salon may promise "vibrant, youthful, firm skin," but in reality, the most important aspects of a professional facial are the steam and masks treatments, which really help to clean the skin, and the hand massage with lotions, which soothes it.

It's also important to find a place where you'll feel welcome. Some salons that solicit men still have a "women's club" atmosphere and there are few things more uncomfortable than sitting in a waiting room, being looked over by a carefully manicured receptionist, provided with only women's magazines to read and surrounded by several ladies, who for some reason seem to always choose these places to talk about their most intimate problems. There are skin-care facilities with a masculine atmosphere where you can get a good facial without feeling foolish.

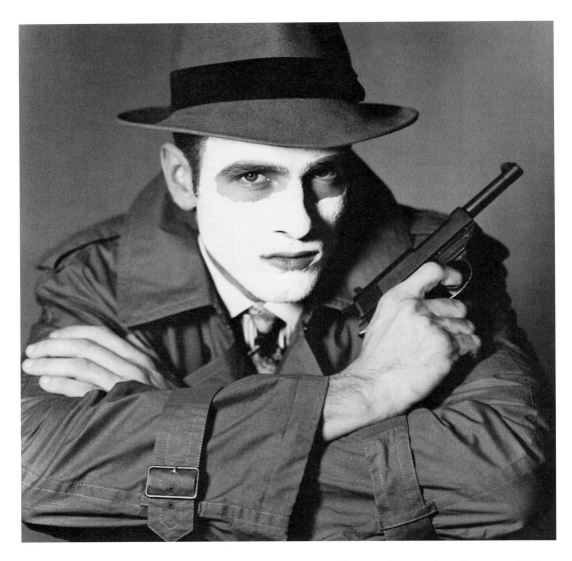

Also, avoid the sale's pitch that usually accompanies the treatment. It's hard to say no to a woman who is gently caressing your face with something that smells good, but chances are you don't need the deep-skin treatment, special eye cream, or lustrous skin food she's selling.

Face masks can be useful for both dry or oily skin. If you have oily skin use a clay or deep cleansing mask, which will help clear out and refine pores. Moisturizing masks can be valuable for men with dry skin. As with virtually every other product you buy, however, it's important to take note of what the mask is made of. For example, some glycerin masks labeled "moisturizing" contain alcohol, which is, of course, anything but moisturizing. (For that matter some cream moisturizers also have alcohol in them, which is equally counterproductive. Men with dry skin must always use alcohol-free products.) You can actually increase the effectiveness of a moisturizing mask by applying some kind of beneficial treatment,

such as a little natural oil or an emulsion (both of which are available from skin-care companies) under the mask. Wash your face first to open the pores, then apply oil, add the mask, and leave in place according to the package instructions. After removing the mask, clean off the skin and close pores with a toner. If you need a moisturizing mask, naturally you put moisturizer on after toning.

■ A heavy-duty night treatment for skin starts with washing the face, then applying a thick moisturizer. Next take an ice cube (the moisturizer protects the capillaries) and "iron" the face, moving the ice cube up and down over the skin. This is actually a very intelligent procedure since moisturizers only work to hold moisture on the skin. The ice cube provides wetness that is trapped by the cream while the coldness closes in the treatment and seals the skin, moisture, and product. Wipe off the excess, leaving a thin film of cream behind, and the next morning your skin should look great. (Incidentally, as the beard grows through the moisturizer during the night, it is automatically lubricated so even shaving is a little easier.)

A Word About Camouflage There's no question that makeup for men is a somewhat explosive subject. Some guys are ready to fight at the suggestion, others are a little curious about what a bronzer or cover stick can do for their complexion. The main thing to remember is that *any* kind of coverup used by a man must be absolutely invisible. And even if some companies do provide men with eye makeup, lip toners, etc., they are best forgotten.

However, covering up blemished skin or giving the face a healthy glow is perfectly acceptable, provided it's done intelligently and with restraint. Surely no one thinks that important celebrities, sports stars, or even presidents appear in front of the public looking palid and drawn, regardless of what their schedules might have required them to do. And there's no reason the average man has to either.

There are essentially only two kinds of cam-

ouflage that make sense for men. The first is a simple cream or powder makeup base used to cover the skin, evening skin tone, covering dark circles under the eyes, and hiding blemishes. If you choose to use one of these products, pick the one that most closely matches your own natural skin tone. Don't try to go darker or lighter, you'll only end up looking strange with lines that clearly mark off where you put on the product and where you didn't. Before applying the product, make sure you have some moisturizer on your face. Your skin shouldn't be wet, but if it is totally dry the product will be difficult to smooth on and it may be absorbed into your skin, which can be disastrous—particularly if, as most men, you're oily in some areas and dry in others. The moisturizer gives you a smooth, even surface on which to work. Use a sponge to apply the base product, moving across the face with even strokes, making sure that the eye area is not too heavily covered (it can show here first). Also, if you're applying cover to hide dark circles under your eyes, never let the product go into the area between the circles and the bottom of the eye. This will just make the dark circles look darker. Cover only the dark area, blending into outlying areas. Once you have covered the face, wait a few moments, then take a clean sponge and go over the entire face, removing any excess. Then spritz the face with pure water which helps set the makeup and also plumps up the skin under the product. Never go below the jaw line with the product—makeup on the shirt collar is horrible. If you can't blend the product into your jaw line you've got the wrong color base.

The second method of adding color is by using a bronzer. The biggest problem with many of these products is that they tend to turn orange or yellow on the skin. There just aren't that many men with a healthy tan who are either orange or yellow, so it's pretty obvious to any interested observer what you've got on. Find a product that goes toward the red tones. Again, a moisturizer is very impor-

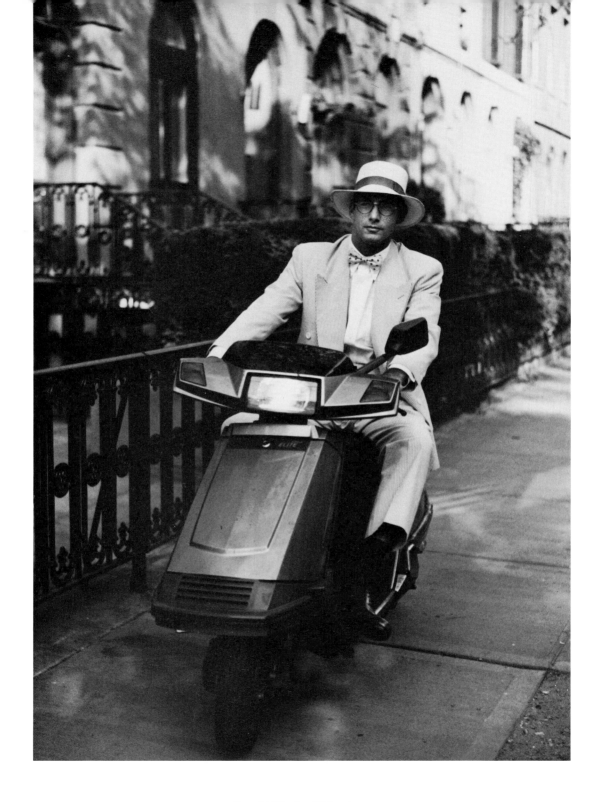

tant as a base for these products. However, don't use a cream moisturizer. Cream products are absorbed more easily than oil by the top layers of the skin. And if the bronzer combines with the moisturizer and is taken into the skin, it can contribute to blackheads and blocked pores, to say nothing of a really terrible-looking complexion. Use an oil moisturizer before applying bronzers. As with the cover-ups, use only a small amount.

With bronzers it's not necessary to cover the whole face. Applying bronzer on the top of the forehead (at the hairline), across the nose, and over the cheekbones, and blending it into the surrounding areas, should give you the "essence" of a healthy appearance. To cover the face with a bronzer means that you must include the ears, back of the neck, down the front of the neck, your hands, and on and on. Just a little on the key areas that normally tan first will take care of "looking like you got a little color."

A Word About Skin Cancer In 1980 the incidence of skin cancer was approximately 1 in every 250 people in the United States; by 1990 the number of individuals with skin cancer rose to 1 in 120. The most common form of skin cancer is the basal cell carcinoma. It affects over 400,000 people each year and it is estimated that 1 in 8 Americans will develop skin cancer.

These frightening statistics make a clear point. The sun is dangerous. And although all the talk and warnings haven't made a noticeable dent in the number of people who still bake on the beach, the least you, as an intelligent, aware man, can do is guard against doing any unnecessary damage to yourself.

Obviously, the area that is the most exposed to the sun is your face. The lighter your skin, the more susceptible it is to the damaging rays of the sun. Consequently, it is important that light-skinned people in particular take adequate precautions. There are many good moisturizers with sunblocks. However, make note,

sunblocks are tested *indoors*, not outside under real climatic conditions. Consequently, it has been estimated that sunblocks, in reality, are only half the strength of the label. For example, an SPF (sun protection factor) of 18, considered the appropriate amount of coverage for adequate sun protection, is only about 9 in the "real world." So, if you're really concerned about protecting your skin, double up on the protection level.

A Word About Cosmetic Surgery It is hoped that by now all the old prejudices and fears associated with cosmetic surgery are gone. These procedures are *not* just for the rich, the famous, the self-indulgent. Cosmetic surgery is for anyone who feels he wants it. And there *are* legitimate reasons for wanting it.

Now, lines and wrinkles may not bother you . . . and certainly there's nothing wrong with wearing your badges of experience proudly. There are two considerations, though, that you may want to keep in mind. First, saggy eyelids, pouches under the eyes, or a loose neck can be both annoying and unattractive, particularly in a face that otherwise is in pretty good shape. And if, when you look at yourself in the mirror, you continually notice the flaws, you might feel better if you check out the possibility of having things fixed. The second problem is not your age but the perception other people have of you when they know your age. Most men today, because they exercise, take care of themselves, and pay attention to their clothes, feel and act much younger than they may truly be. But as soon as they announce they're getting up there, everyone around them tends to treat them differently. Frankly, there's not a thing wrong with lying about your age. It's nobody else's business anyway, so why not pick a good year and hang onto it for a while? And if a little lift and tuck help you do this, then go for it.

There are a few things you should keep in mind when you start thinking about cosmetic surgery:

- Only have cosmetic surgery if *you* want the procedures. Don't let anyone talk you into having something done.
- Being in good physical shape will make your recovery quicker and easier.
- If you need to lose weight, lose it before you opt for any procedure that involves skin removal. Otherwise you might just find yourself with loose skin all over again if you lose the weight later.
- Think about what you expect from the surgery. A good reason for the procedure is that you plan to improve a specific feature of your appearance. A bad reason is that you don't get enough dates, are lonely, and expect the work to change your whole life. Chances are it won't.
- Once you're committed to the procedure, make sure your surgery is done by a good doctor. Your surgeon should belong to the American Board of Plastic and Reconstructive Surgery; a branch of this organization that deals specifically with cosmetic surgery is the American Society for Aesthetic Plastic Surgery.
- After surgery, don't mistreat your skin the way you did in the first place—otherwise you'll neeed it done again very soon.

Speaking of cosmetic surgery, it's interesting to note that one area where enormous cosmetic strides are being taken is in teeth. It is now possible to have your teeth straightened, colored, or filled in. In fact, a good cosmetic dentist can do virtually anything. Taking care of your teeth is naturally a basic part of good grooming. And if you have particular teeth problems that distract from your appearance, having them fixed is certainly something—as an intelligent man of style—you should investigate.

PART III

The Hair

Men like their hair to look nice because it's one of the few things about their personal appearance that is immediately apparent (since even the best bodies have to hide under clothes sometimes), and that they can actually change without being embarrassed. Women can change their looks almost entirely with makeup, or wigs, for example. Men don't, thank God, have those options (or difficulties). Not all men have hair, either, but that'll be discussed later. Men who do have hair often spend a lot of time on it . . . sometimes with disastrous results.

A few years ago, the big news was that men were going to hairstylists instead of barbers and that men's haircuts were becoming as expensive and as time-consuming as women's. There's nothing new about this situation anymore, and it's not likely that men will ever totally retreat back to the simple barbershop for a quick clip. The future is more than likely one of increasingly expensive and time-consuming ordeals during which the male becomes as neurotic and as particular as any old-time movie actress.

The difficulty with this trend is that men are now succumbing to the same silliness about their hair that women have always had. And, straight out, it's important to state categorically that among the great fallacies propagated on an unsuspecting public is that there is sense in "hair fashion" for men. This idea is both practically and fundamentally ridiculous. Admittedly, as an individual grows and changes, his hair should reflect the altering of his facial features and bone structure, perhaps even his position in the world, and for many men, a certain amount of hair loss. But the idea of a man's changing his hairstyle to conform with the latest cut is absurd. A man's basic head doesn't vary from season to season, and if he's found a haircut that works on him, he has no business changing it just to keep in style. And nothing will make a man look dumber than getting his body in shape, taking care of his skin, buying the right clothes, and then letting his hairstylist try out his latest inspiration or "make a statement" with his hair. This whole business of making statements is silly to begin with. Who wants to hear from their hair anyway?

Although some men like messing with their hair, combing and spraying it, most men want their hair like everything else around them—comfortable, easy to maintain, and looking good. And the simplest, most direct road to that goal is by getting the right haircut.

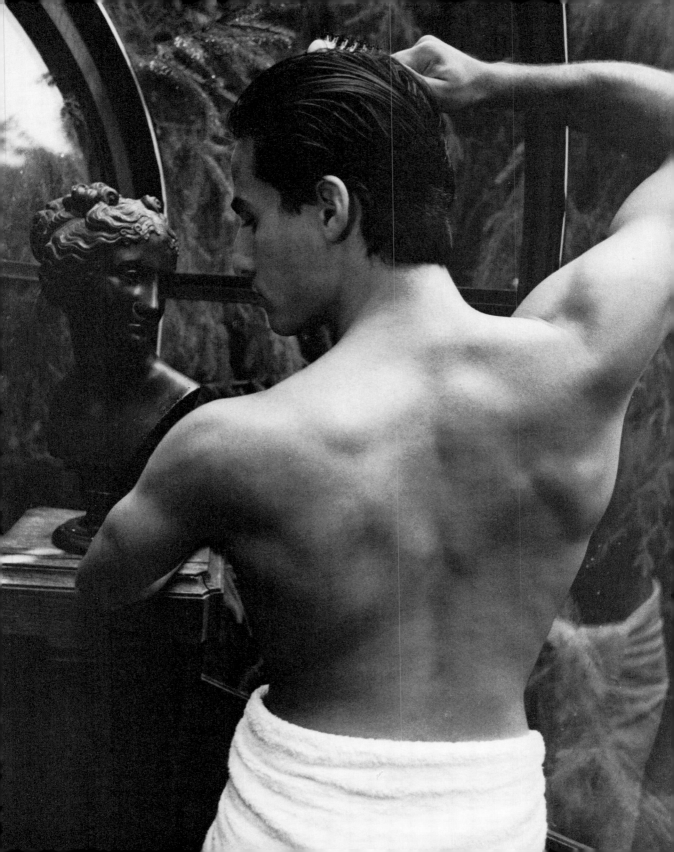

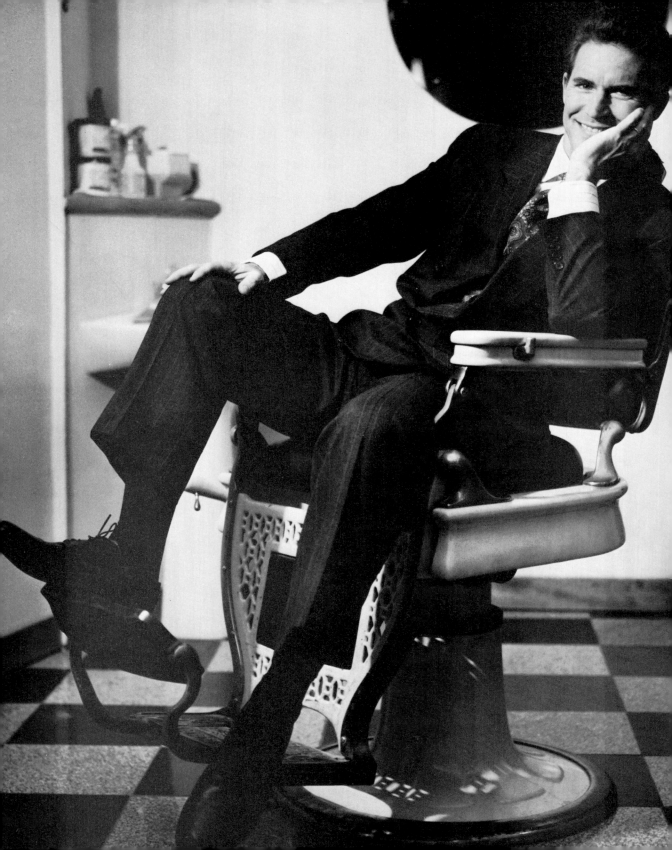

Chapter 7

Haircuts

Talking to a hairstylist can be a difficult process. There is a fine line between finding a good barber and letting him do his work and knowing when to say "enough." Some hairstylists are so intent on displaying their artistry that somehow they forget all about the client. No man wants to be the victim of a hairstylist's sudden urge to be creative. But by the same token, not even the most capable, caring, and talented stylist can change the basics of a man's hair growth and structure. Each man needs to recognize the naturally occurring good and bad points of his hair, realize his lifestyle requirements, and come to terms with what he will and won't do to keep his hair the way he wants the barber to cut it.

The bottom-line emphasis here is on the right cut. Models need haircuts that are functional, versatile, and directed toward bringing out the best of their facial features. A model's haircut can bring him work or cost him work.

Some models with trendy cuts have lost jobs because their image didn't fit with the product, or the client knew that in a few months the pictures would be worthless because the haircut would be "out of style" (though what he was doing with a haircut "in style" in the first place is a question no one seems to want to answer).

The point about versatility is important simply because a well-cut head of hair *is* versatile and if it isn't, it's not a good haircut. If a man's hair can only be combed one way, even if he doesn't want to try other styles, then the haircut isn't well done. A head of hair that will only go one way means that the hair (and incidentally the hairstylist) are in control, not the man himself, and he becomes a slave to his hair, rather than having his hair be a servant to his total presentation. The single-look haircut is reminiscent of the old television situation comedies when a young man was unable

to get his cowlick in place before the big dance. Today a good haircut doesn't have these problems, simply because if it won't work one way, it works another. A good haircut can be slicked back, loosened for a casual appearance, combed conservatively . . . whatever you want it to do. This is particularly helpful if you go to the gym regularly or are into sports, simply because it's a lot easier to just slick back your hair after strenuous activity; if you have a funny haircut, you'll find little hairs sticking up all over your head when you try this. By the same token a haircut that can't be actually combed into shape will be a problem when you're in a hurry.

To create a versatile haircut, the basics are simple. The cut should be designed for your particular face and hair. Now, this isn't to suggest that the method and means by which your barber does the job has to change for each person who comes through his shop, but the manner in which he deals with the scissors has

to be adjusted to each individual. In general, fine hair can be made to look fuller if the hair has a blunt cut. Thick hair that is difficult to manage may need to be thinned. (Never let anyone do this with a razor; it thins the hair too much, making it look sparse.)

Regardless of whether short or long sides are "in vogue," the cut on the sides of your head is determined by the shape of your face. Men with wide faces will find that the lines of their faces are enhanced by short hair on the sides, men with narrow faces will have a more symmetrical appearance if the hair on the sides of the head is longer. These are not hard-and-fast rules, obviously. A man's life-style and face really determine the way his hair is cut. The point is that the bottom line really depends on what *you* know about your hair. It's simpleminded to just sit down and let the barber have at it. So take a few minutes to understand your hair.

- Is it coarse, fine, thin, dry, oily?
- Is your hair thick or thinning in some areas (or maybe a little of both)?
- What is the pattern of growth?
- Do you have "nice" hair or is it just . . . hair?

If you can't, on your own, figure out these things, then find a hairstylist who can and will explain them to you. Which brings us to "going to the barber."

If you have any doubt about where to go for a haircut, just ask anyone you know. Chances are they all have someone who is "really great." It's hard to understand the affinity that is established between some people and their hairstylist, but it would appear that for a few people the loyalty they feel for the individual working on their hair is akin to the kind of idolatry that has lead whole nations to follow some demigod into war.

You choose a barber by how they cut your hair. As simple as this sounds, some men don't seem to get the point. If the man who sits next to you at the office has a full head of hair and a great haircut, that doesn't mean that same barber can do a good job on your thinning, fine hair. It doesn't mean that he couldn't, either. But the easiest way of finding a good barber is by first locating someone who's hair most closely resembles your own and looks good. Ask where he gets his hair cut and make an appointment. If you don't know anyone who has hair like yours and you're too shy to ask a stranger, then you still have a couple of options. Check with a friend who always looks good or find out where the executives of your company go. (Along with a good haircut, you might be able to spend some quality time helping your career while you and the boss are waiting for the barber.) Another option is calling the local paper and asking the life-style reporter for the name of a good salon. As much as these people may not want to be bothered with this kind of inquiry, chances are they know what's going on in town.

The number of places you can go for a haircut depends naturally on where you live. Smaller communities may only offer the simple barbershop or shopping mall unisex emporiums (which, for the most part, are the most likely locales to be guilty of trendy cutting). In big cities, the average man can find everything from very grand facilities staffed with oppressively chic stylists who view them with hauteur to simple two-barber operations where the haircut is a considerably less important topic than the latest doings in Washington D.C.

It's hard to understand why getting a haircut has turned into something of a social engagement. Men don't spend their workout time visiting or have a long conversation with their shirt salesman while shopping. But, for some reason, the minute a man sits down in the barber chair, it's time to talk . . . about virtually everything but the job at hand. You go to the barber to get a haircut. It's an important part of your grooming process and your focus should be on what's happening to your hair.

On first sitting down at a salon, a man should expect the barber to ask a few ques-

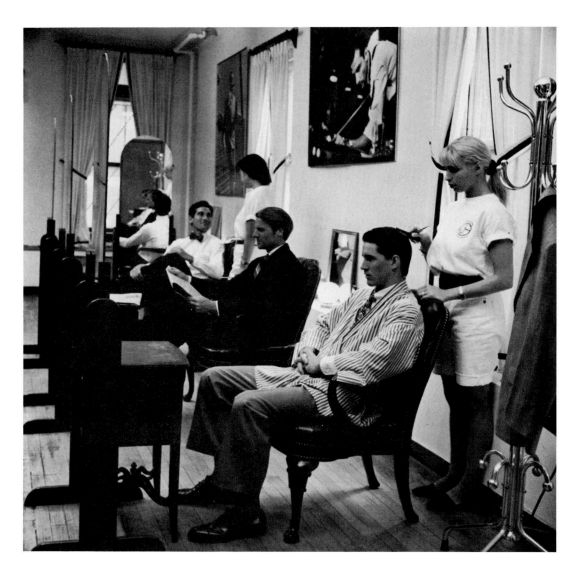

tions . . . about his hair, life-style, interests, schedule. Under no circumstances should you allow him or her to just start cutting. If you're afraid to talk to a particular stylist or are intimidated by your surroundings, then you have no business in that particular salon in the first place. If the stylist isn't interested in discussing your haircut you have the right (actually the responsibility) to get up and leave.

The barber should be interested in discussing your professional and business requirements, the amount of time you have in the morning, whether or not you work out (since going to the gym means fixing the hair again after exercise), and most of all, just what personal image you want your hair to promote. You should discuss your hair itself, any problems you have with it, the condition of it, and

how it grows. Of course, the intelligent man is realistic about his goals and won't, if his hairline is receding and the crown of his head is bald, take along a picture of a long-haired rock singer as an example of the way he wants to look. But it is actually astonishing what can be done and too often isn't, simply because the client doesn't require it and the barber has a lot of other men waiting and can't be bothered.

If once you get the "perfect" haircut, don't take any chances of never getting it again—take pictures. Get someone to shoot the sides, back, and front of your haircut and take these shots with you the next time you go to the stylist.

A good haircut is not determined by the way you look when you leave the salon, but rather by the way your hair looks the first time you shampoo and dry it on your own. Don't complain because you can't get it to look exactly the way the barber did. You'll never do this, simply because he or she is working from above your head; you're working from below, and can't get your hands into the same posi-

tions the barber did. But still, if it's cut right, it should look great.

A Word About Sideburns The great battle of the sideburns is often the average man's hair Waterloo. Sideburns finish off the frame that hair creates around your face. It's dumb to remove them. And the way they're cut is also another example of the silliness propagated by hairstylists about hair fashion. Regardless of what's in vogue, sideburns don't need to be extra long, come to a point, or anything else strange. For virtually every man who has a full head of hair, the length of his sideburns is determined by the shape of his face and his cheekbones.

A man with a wide face should grow his sideburns to the bottom of his cheekbones. If he has an average-shaped face, sideburns should be in the middle of the cheekbone. For a man with a narrow face, sideburns that just touch the top of the cheekbone are best. In all cases, they should be squared off and kept neatly trimmed.

Chapter 8

Hair Care

For a model on the set of an editorial layout or commercial print assignment, hair care can usually be translated as "bring on the gloop." During a normal shooting, a model can find his hair spritzed with water, filled with styling aids, sprayed, brushed, resprayed, doused with mousse, and sprayed some more. Due to the constant heat from the lights, the movement, changes of clothes, and general chaos, most of this fixing and refixing is necessary. Perhaps that's why models choose to leave their hair alone as much as possible when not working.

For anyone interested in keeping his hair looking its best, it's wise to have at least two, or even three, different shampoos. Using the same product over and over can result in shampoo "buildup" in which the product loses its effectiveness over time. (This is equally true of dandruff shampoos to which the scalp can become "immune" and consequently re-sistant to the medicinal action.) So change shampoos regularly to keep a fresh appear-ance and assure that the hair is truly clean.

Unless you have a special hair condition (tinted, permed, damaged) that requires a par-ticular kind of product, the best shampoos for the average man are the lightest, least deter-gent-based products—the only difference be-tween some commercial shampoos and the products used to wash cars is perfume—with-out alcohol, which means no "added smell."

Conditioners are, along with shampoos, per-haps the most overused hair products. Falling victim to media propaganda, many men as-sume that they must condition their hair every time they shampoo. Actually, unless a man's hair is particularly dry or damaged, condition-ing is only really necessary a couple of times each week. Overconditioning makes the hair limp and difficult to style.

Styling aids, in general, are confusing. Gels,

fixatives, mousses, oils, lotions, creams, and sprays are all available and almost every man has at least a few of these preparations in his bathroom, most of which he's unsure how to use.

Essentially, gels contain many of the same ingredients as hair sprays (copolymers). The gel form of these products can give greater hold than sprays on hair since they don't just coat the outside of the hair shafts but can actually be spread through the hair. The amount of hold depends on the strength of the copolymers (light hold products have less concentrated copolymers). By the same token, mousses are simply styling lotions in a different form. However, while a styling lotion can provide very heavy hold, the foaming quality of a mousse actually reduces the strength of the product. Nonetheless, mousses in general offer greater hold than gels.

In general, less is always more when it comes to any styling aid. They should be applied to slightly damp, not wet, hair and combed through. Mousses should be used on damp or rainy days because they provide the most hold and body. Gels usually leave the hair freer and more casual while adding body to the hair follicles. Creams and oils are only really helpful when a man wants to simply comb his hair straight back in a slick style. (At one time the "wet look" was achieved with gels, but this resulted in stiff, flaky hair. Now, if a man wants the slicked-back look he uses an oil or cream that remains soft and actually greasy.)

The great problem with hairspray is that most men simply use too much of the stuff. There is no reason why any man should have stiff, rigid hair just to keep it in place. Hairspray should not be sprayed directly on the hair; rather it should be sprayed on the hairbrush and brushed through, giving hold and firmness to the hair without locking it in place.

To make a normal head of hair look nice in the morning, follow these simple steps:

1. Shampoo. Only one time. You have to have a very dirty head to require two shampoos. It's hard to understand why shampoo manufacturers suggest repeating the process, although one wonders if perhaps this isn't just a way of encouraging people to use more shampoo.

2. Rinse well.

3. Condition if necessary.

4. Rinse.

5. Towel dry excess water from the hair.

6. Comb hair straight back and leave in place while drying the rest of the body, shaving, etc. (See Part II, The Face.).

7. Apply mousse or gel, depending on the weather, the condition of the hair, and the day's activities.

8. Comb straight back.

9. Leave alone until almost dry.

10. Blow-dry, or comb into place and allow to dry naturally.

11. Spray brush with hairspray and brush through hair.

A Word About Baldness It's difficult to know exactly why men think of losing their hair as a major catastrophe. Perhaps they see it as a loss of their sexuality or a sign of growing older. In reality it has nothing to do with either. And it actually doesn't affect a man's

potential to look good . . . provided, of course, he handles the whole thing intelligently.

Most hair loss is genetic. And if it happens, you have the choice of trying to fight it or simply working with it, just as you have to work with any of your other personal physical limitations.

Now, there have been some scientific advances made in hair-loss treatments. And for some men, these can be beneficial. There are also surgical procedures that can be helpful in restoring hair. But if you have neither the time nor the money to invest in these endeavors,

then you just have to bite the bullet and be bald. And the most important thing to keep in mind in this situation is *there's nothing wrong with it,* provided you don't do anything stupid.

If your hair is thinning, have your barber cut it to look its best and keep it neatly combed. One simple way of both camouflaging and taking care of a balding head is to simply cut the hair very short. Short hair is easy to maintain and you don't run the risk of looking as if you're "trying too hard."

Don't even think about making a statement with your hair such as letting what's left grow

long enough for a pony tail. That's really strange.

And certainly don't ever attempt to cover hair loss with the obvious methods such as letting one side of your hair grow and then combing it over to cover a balding pate. This is particularly dumb and unsightly.

Hairpieces and wigs *might* be a solution. But unless you're willing to invest *very* heavily, chances are your rug will look exactly like that —a rug. And rugs belong on the floor, not on anyone's head.

You may be better off just not worrying about your hair loss. Besides the fact that stress is one of the biggest causes of baldness in the first place, if your lack of locks is the most interesting thing about you, then you've got problems considerably larger than a receding hairline.

The only thing about hair loss that is really serious and requires consideration is the exposure of the skin on top of the head to the sun. If your hair is thin, wearing a hat in the sun is very important. Skin cancer (see page 57) can be particularly dangerous for balding men. So keep your head covered.

Chapter 9

Hair Problems and Solutions

The most prevalent hair problem is doing too much with it. The solution is to knock it off. *Don't* get a "trendy" haircut, spend hours coaxing your hair into shape, stop your workout to comb your hair (which really makes you look stupid), use gobs of hairspray —you know the kind of stuff. When in doubt, don't do it. Still, you must take care of your hair, particularly if you have some problem.

There's nothing that kills off a man's total look faster than dandruff. This condition is completely unacceptable because most times it can be cured or at least controlled. Occasional dandruff, which is really a scalp problem, not a hair problem, can usually be taken care of with a dandruff shampoo containing sulfur, salicylic acid, or selenium sulfide. However, many men, maybe without noticing it, can become immune to any of the commercial dandruff shampoos, so it's helpful to change products occasionally in order to get effective dandruff control. Very bad dandruff may require the help of a dermatologist.

Many men have a cowlick somewhere on their head. For most this seemingly uncontrollable patch of hair is located in the back near the crown area. Find it, point it out to the barber, and ask him to deal with it when he's cutting. When you're combing your hair, you can use extra gel to get this area under control or comb away from the area so it will fall into the other hair.

Dull hair can be brightened with a little vegetable oil or nonpetroleum jelly applied after the hair is washed and dried. Dry hair can be treated by simply applying a little vegetable oil before shampooing. Oily or overconditioned hair needs to be cleaned often. It can also be rinsed with either vinegar (dark hair) or lemon juice (blond hair).

Hair Color

Perhaps the fastest-growing grooming process for men is hair coloring. But like any other personal endeavor there are right and wrong ways of doing it.

To begin with, chances are a professional will call hair dyes hair tints these days. It seems that men are less intimidated by the idea of tinting their hair than dyeing it, even though it's essentially the same process.

There are a lot of different coloring processes these days: permanent tints, semi-permanent, stripping, bleaching, rinses, highlighting, and on and on. However, most men are really only interested in permanent coloring or highlighting.

Permanent Hair Coloring When permanent hair tints are applied to the hair, they open the hair shaft and deposit color in one step. This procedure is "permanent," until the hair grows out, unless another color is applied. Although the accepted wisdom is that tinting hair is bad for it, actually the process can add body and firmness to otherwise difficult-to-control hair. However, it is important not to overdo it. Permanent hair color should be applied only once every three or four weeks.

But the most important consideration is color. Despite the fact that there are many products on the drugstore shelves that promise you safe, simple at-home color, to get a natural, properly shaded hair color—to do the job really well—most likely you will require the services of a trained professional. The selection of the color, mixing, strength of the tint, and amount of time the color is left in place are all important when it comes to doing a good job. And few men are capable of handling all this on their own.

Please don't just "drop" in at a salon for a new hair color. This is a procedure that requires some thought and preparation. Always remember that when it comes to hair color,

less is more. Whether you're covering gray, lightening your hair, or darkening it, don't let (or insist) the colorist go full speed ahead the first time. You can always add more color later. The first time should result in only a slight, gentle color change. If everyone notices that you dyed your hair, you went too far.

Make sure you know what process and procedure is being used so you have an idea of what is going on and in case you have some kind of allergy to the products. Discuss the up-keep and proper care of your hair after the tinting job is finished. Again, if the colorist is not willing to talk, get up and go somewhere else.

Despite the fact that having hair colored professionally is the best method, some men may still insist on trying it themselves. If you're one of those, then don't just pour a permanent tint on your hair and hope for the best. Start by using a semipermanent tint or a rinse. When it comes to color, the selection must be made based on your natural hair color. If you have dark hair and are trying to cover gray (the reason most men tint their hair) then choose a color at least one shade *lighter* than your natural color. The worst thing you can do is try to match your color or go darker at this point. Blonds, however, who are trying to cover gray should go one shade *darker* than their natural hair color. They should also chose an ash shade to avoid brassiness.

If the at-home product suggests a patch test, do it. Also follow other package instructions. This is no time for the novice to get creative. Don't do anything drastic. Keep it simple.

Incidentally, if your eye is wandering around the hair-color section and happens to fasten on one of those gimmicky products or preparations outside the normal range of hair coloring, just keep on looking.

Highlighting This is a procedure that is so perfect for men it's actually surprising that more don't have it done. Of course, it *must* be

done by a professional, but in terms of time, effort, and expense, it's certainly the best buy in the hair-coloring market.

Highlighting is a process by which selected strands of hair are colored. This procedure can brighten hair, give it highlights (of course), and is very effective at camouflaging gray. The benefits are obvious. If only a small amount of the hair is colored and the tint doesn't go to the roots, there's no concern about covering new hair growth constantly. Highlighting lasts longer than permanent colorings simply because it's often difficult for anyone looking at the hair to tell what part of it is colored and what isn't. Consequently, the whole thing is cheaper and easier to maintain.

If you choose to have your hair highlighted, again the expertise of the technician doing the job is the main ingredient. Find someone who really knows about the process and discuss it thoroughly before ever letting him start.

As a general rule of thumb, blonds can lighten their hair with highlighting as much as they want; however, men with darker hair should only highlight within the framework of their natural color. For example, a brunette could have quiet gold highlights (which are very helpful in covering gray) while men with black or very dark hair should head toward the *subtle* auburn tones.

Highlights should look natural, giving the impression you've been in the sun for a few weeks. Nothing drastic or shocking, just a little brightness.

Although most colorists resist the idea of highlighting very dark hair (preferring to either do a permanent tint or leave it alone), the only condition that is truly resistant to highlights is when a man's hair is fully gray. After all, what do you lighten it to? However, there is an alternate process for gray hair. (Did you think there wouldn't be?)

Reverse highlighting weaves color through the gray without touching the hair you want left alone. With this procedure, in effect, rather than color being removed by highlighting, it is actually being put into the hair the same way it would be taken out, without touching the roots or causing a man with gray hair to suddenly appear with dark hair. It is a subtle, gentle way of camouflaging enormous amounts of gray without making a man look absurd.

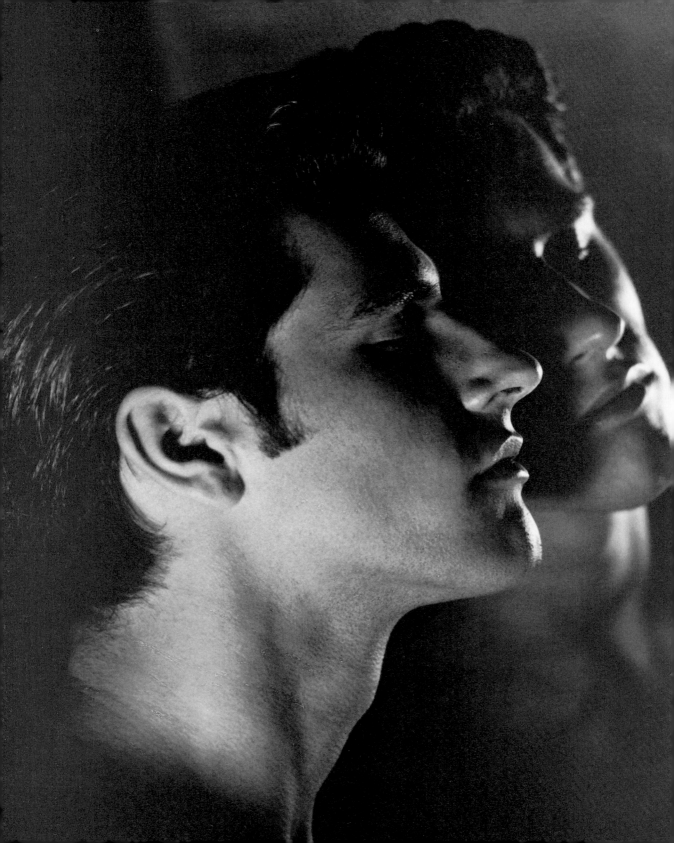

Chapter 10

Hair Tools

Several of the Zoli men don't even own hair dryers. They don't like being bothered and hate the "puffy" result they get from them. They dry their hair with a towel, put in whatever products they're using, and let it dry naturally.

A hair dryer can be a helpful styling tool, but only if it's used correctly. It is ridiculous to try and duplicate the blow-drying movements of a hairstylist in a salon. After all, these people are standing above their clients and have a better vantage point from which to work. The puffy effect some models complain about is the result of directionless hair blowing. Another problem occurs when a man, attempting to add fullness to his hair, blows it backwards. Unfortunately, this procedure usually results in "big" hair which looks absurd.

For regular blow-drying, a hair dryer should be held in one hand, a brush in the other. The dryer should simply follow the brush as it moves through the hair. If a man wants to add volume to his hair, he should place the brush under the hair, lifting it slightly, and blow dry from the top.

The average man will be most comfortable with the smallest 1,200-watt hair dryer he can find. The small appliances are less intimidating to use, easier to handle, and more convenient to pack for business trips.

The little plastic comb that most men used to carry around is still a helpful tool, although most models prefer to stick a brush in their business bag. If a man has a conservative style, a comb will usually suffice for quick touchups. However, a brush will give him more control over his hair simply because it's stronger and larger. Brushes must have soft, natural bristles. Hard bristles will actually tear the hair and even the scalp.

There is no reason for men to invest in scalp massagers, curling irons, or any of the rest of the electric hair tools that litter the small appliance section of department stores.

Simple Solutions

■ A conditioner can be a helpful means of getting hair in shape without shampooing. This procedure is beneficial particularly for men with dry or difficult-to-control hair who don't like to shampoo every day. Conditioner washing doesn't truly clean the scalp so it can't be done day after day, but if you shampoo every other day, on the alternate mornings simply wet the hair thoroughly, apply conditioner, leave it in place for a minute or two, and then rinse out. Conditioner used instead of shampoo will give the appearance of clean hair without stripping the hair of natural oils or body.

■ If you've used your hair dryer wrong or just have one of those days when your hair seems to be puffy, simply placing the flat of your hand on the area that's standing up and holding it down for a few seconds will help remedy the problem.

The heat from your hand will cause the hair follicles to collapse.

■ Keep a little bottle of oil, glaze, or conditioner in your gym bag. After your workout if you can't get your hair to comb or lie down properly, just put a little on your hands, rub it through your hair and comb straight back. It's a great look.

Industrial-Strength Endeavors

■ If you want to really give your hair body, after shampooing, towel off the excess water and apply a small amount of gel, comb it through, and apply yet a different gel. Then add a leave-in conditioner (to combat the drying effect of the gels). Comb through. Then apply a mousse and yet a third gel individually, and comb through. When the hair is almost completely dry, use the blow-dryer to separate and lift the hair.

■ To make your hair look shiny and healthy, apply vegetable oil to the scalp and leave in place for a few hours or overnight. Massage the scalp with your fingertips for several minutes before shampooing.

PART IV
The Clothes

Men's clothes are essentially a very simple subject . . . always have been . . . always will be. Despite the efforts of a few avant-garde fashion designers who periodically insist on experimenting with unusual (if not bizarre) fabrics, designs, and combinations, the imaginations of marketing experts who seem to think they can sell anything, and the misguided adventures of the poor men who have become known as fashion victims, clothes for the intelligent man are still a straightforward, no-nonsense business.

It has long been an axiom that "clothes make the man." As trite as this saying is, to a certain extent it's true. But not the way you might think. At the time the phrase was coined, in the English Regency period when men's fashions were incredibly ornate, requiring hours to assemble, the lavishness of a man's garments denoted his stature and position in life. Today, clothes still can help others pinpoint your taste and professional level, but the summation is not based on how grand they are; rather it's almost the other way around. The well-dressed twenty-first-century man appears as if he's owned his clothes for a long time, tossed them on without thought, and wears them without regard. But he can only do this if he has chosen his clothes carefully, had them meticulously fitted, and maintains them perfectly.

Without dismissing the concept that clothes make the man, the man of style is more likely to lean toward Hardy Amies's words, "You don't notice the clothes on a well-dressed man."

Away from the cameras, models choose their clothes for comfort, versatility, individuality . . . and cost. Despite the fact that top male models can make as much as ten thousand dollars a day (which helps explain why so many men are trying to get into the business these days), both beginners and seasoned professionals avoid investing more than necessary in their wardrobe. The new model usually just doesn't have the money, and the established, intelligent model is concerned with keeping what he's made, rather than spending it on clothes.

Models are almost immediately made aware that wearing garments that are too distinctive or unusual can take attention away from them, while clothes that are shabby or cheap-looking, too fashion conscious, even too perfect, will distract from or drag down their personal presentations. A model's clothes, like his grooming procedures, must act as a backdrop for his "look," reinforcing, not overwhelming, his image.

This premise is equally true for the average man. The way a man dresses both affects his own self-image and the image he projects to his friends and associates.

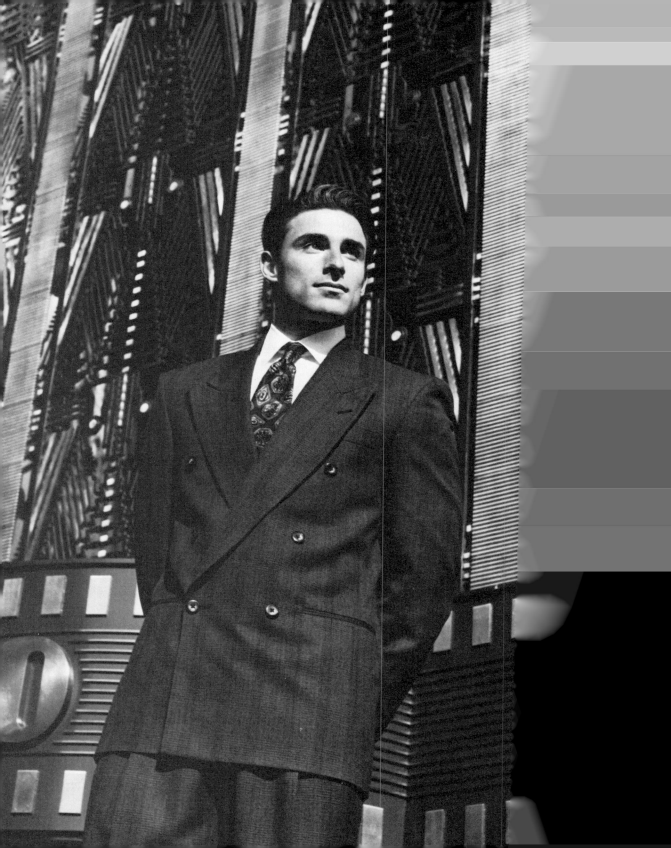

THE FOUR BIGGEST MISTAKES

• **Too much is too much.** The man who is overly clothes conscious runs the risk, and usually falls into the trap, of being perceived as somewhat superficial. Also, wearing the very latest fashion innovations immediately upon their introduction can make a man appear to be a slave to his wardrobe. This is neither professionally helpful nor socially comfortable. The model, like the average man, who appears in a business situation wearing a trendy new suit, the latest shoe style, and most current tie, usually finds that his clients are more interested in his garments than in him.

• **Not enough.** It might be assumed that only people who don't have to look good for their jobs ignore dressing well for work. But there are corporate executives, Wall Street bankers, and high-powered lawyers who seem to be unable to get it together. They go off each morning wearing unkempt, sloppy, and even soiled garments, run-over shoes, and spotted ties. It's possible that a business genius can get away with this kind of personal presentation, but the average man looking to climb up the corporate ladder will certainly find that this lack of personal care will work against him.

• **Perfect isn't perfect.** Some men err in the other direction. Anyone who is too meticulously dressed, carefully ironed, fitted, and buttoned up, gives the impression that his clothes are wearing him, not the other way around. A man who looks too perfect, too stiff and unyielding, is almost immediately distrusted by coworkers.

• **Minor mistakes make a big difference.** There are men who often give the impression that they're just not finished. They may be wearing a good suit and tie, but the shirt is

the wrong color, or their cuffs are too short or too long. Although the man who makes little errors is in better shape than the "perfect isn't perfect" individual, he still isn't taking full advantage of his personal appearance to support his professional and social image.

The most important part of investing in, creating, and maintaining a wardrobe is not the amount of money spent or the time involved, it's making intelligent choices when selecting clothes and putting them together with taste and style. This may not be the kind of stuff stars are made of. But it is the kind of stuff that makes men of style.

And speaking of stars . . . when was the last time you made a major movie or showed up in a hit music video? Well, if these endeavors are not a regular part of your life, then why on earth would you chose to dress like the people who do those things? If you take careful note, many of the better-dressed people who make movies and videos don't get themselves up in bizarre outfits when they're not working. Another wrong image for the man of style to copy is that of the models who appear in magazines. Very few men look like these models, and even if they do, duplicating a fashion editor's sense of style doesn't leave much room for individuality.

So who does the man of style look to for guidance? It's simple: his own well-tuned and intelligent taste which has been trained and cultivated by study and investigation. Clothes for the man of style are yet one more backdrop for his individuality and personality. He assembles his wardrobe carefully, picking it for durability, taste, longevity, fit, appropriateness, and coordination potential. The point is not to choose unusual things in order to create a distinctive image; the man of style chooses the basics, then *puts* them together in a manner that keeps him within the bounds of good taste while still giving him an edge of individuality.

Chapter 11

Creating
a Wardrobe

Some men just have closets with clothes in them; others, intelligent and thoughtful guys, have wardrobes. Wardrobes don't just happen, they're carefully thought out, put together, and assembled. The man who just buys something because he happens to like it without giving any thought to the rest of his clothes or to where the new purchase will fit into his wardrobe (and incidentally his life-style) is running the risk of wasting money, time, and effort.

A wardrobe begins with the basics, clothes that are appropriate for virtually every well-dressed man. The reason they work for so many men is that they *are* "basics," traditional garments that have been accepted as classics, are constantly in good taste, functional, adaptable, and handsome. These garments didn't just "happen" to become classics. They made it to this level by virtue of their durability, taste . . . and, of course, style.

Because there's an inherent elegance to classic clothes, some men make the mistake of assuming that they're only for the rich or that they're dull. Both of these assumptions are wrong.

Admittedly, every well-dressed successful businessman most likely does own the garments in the basic wardrobe list, but that doesn't mean that every other man shouldn't have the same things. These clothes are within virtually everyone's budget, and they're suitable for any man interested in and concerned about his personal appearance. And they're not dull. They may not be loud fashion statements or the latest trends, but they're sharp, handsome, well made, and masculine, which is all a man's clothes have to be. If you feel you have to wear things that "stick out" in order to make a point or have a personality, then you have problems considerably larger than this book can handle.

Clothes, like any other aspect of your personal presentation, are a backdrop for you. They reinforce your image, highlight your strong physical attributes (camouflaging your weak ones), and help you present a total look to the world.

So here are the basics. These are the clothes the businessman needs to start his wardrobe, creating a foundation upon which he can build, work, or simply exist. From this starting place, using the classics as a guide, any man can create a handsome wardrobe, adding garments that are always in good taste, yet at the same time give him the opportunity to combine and choose from among them to best reflect his own image.

The basic wardrobe will cover just about any event. It is, of course, adaptable for men who don't have to wear suits and ties to work, simply by excluding the business clothes, substituting well-chosen work clothes instead. (There are really few things men look better in than rugged work clothes that have been thoroughly broken in and are comfortable.)

BASIC WARDROBE

This is a list of suggestions, a collection of basic garments that most every well-dressed man should include in his wardrobe. Obviously, each man's physique and life-style are the final framework that dictates an intelligent clothing collection. However, if you start with these items, carefully building on them, you'll have a good chance of creating a sensible and functional wardrobe for all seasons.

Suits and Sport Coats

Gray flannel suit
Navy wool pinstripe or solid double-breasted suit
Navy tropical wool blazer
Tweed sport coat

Solid-color lightweight cotton or cotton blend sport coat
Solid-color lightweight cotton or cotton blend suit

Dress Shirts

A selection of long-sleeve cotton and Oxford cloth shirts in solid white, pinstripe, and light blue

Casual Shirts

Long-sleeve, cotton denim, flannel, and chambray shirts
Short-sleeve cotton Madras shirt
Short-sleeve cotton white and black T-shirts
Short-sleeve cotton solid-color polo shirts
A selection of long-sleeve cotton mock turtle and turtleneck shirts in solid colors

Trousers

Cotton khakis
Gray flannels
Lightweight, wool blend pants in medium brown
Basic jeans
Cotton walking shorts

Sweaters

Solid-color cotton or wool cardigan
Solid-color cotton or wool crew or turtleneck
Bright-design cotton or wool sweater

Outerwear

Trench coat
Casual jacket (leather, wool, or cotton)
Wool overcoat

Shoes

Plain black dress
Brown loafers
Deck shoes
Sneakers

Accessories

Cotton underwear and socks
Black leather belt
Brown leather belt
Leather gloves
Nylon warmup
Silk handkerchiefs (for suit pocket)
Wool or cashmere mufflers
Silk or wool paisley-print ties
Silk repp ties
Wool or cotton vest (for use with sport coat
 or casual attire)
Suspenders
Baseball or stocking cap
Cotton gym shorts

You will note that none of these items "bounce" out at you. They're all quiet, restrained, work well together, and are easily interchanged.

Always keep in mind that a man essentially needs to be "bigger" than his clothes. When you see a celebrity wearing something very dramatic or unique, aside from hoping to get attention or make a point, these individuals are always "on stage," gearing up their personalities so they, as well as their wardrobes, are powerful and eye-catching. (All right, in some cases the clothes are the most important part of a performer's personality, but the less said about these people the better.) The average man is not on stage and he does not need to wear costumes.

A Word About Relaxing Your Wardrobe A few years ago, men in some areas of the world, particularly the "sun states" in America, began lightening their wardrobes, choosing more relaxed and casual garments for both work and social activities: unstructured suits and sport coats in place of traditional suits, turtleneck and mock turtleneck shirts instead of dress shirts and ties, jeans rather than standard dress pants.

A well-dressed man should always appear comfortable in his clothes. And if your professional and social life-style permits, there's certainly nothing wrong with including less formal clothing in your wardrobe, provided you don't equate casual with messy or modern with trendy. Just because you choose to wear relaxed garments it doesn't mean your clothes can be without style or distinction. In fact, dressing casually can require more imagination and sense than simply putting on a suit and tie. Casual clothes should give the same impression of elegance, dignity, sophistication, and ease of the most carefully fitted dress suit. To this end, skill and taste are vital for the assembling of a casually correct collection of clothes.

Perhaps the greatest danger of "loosening up" is the tendency to become sloppy. It really can't work that way. Regardless of what you wear, it still has to fit properly, be carefully maintained, and be clean and pressed.

If you've gone over the basic wardrobe list and noted that you don't need business suits or neckties, then don't buy them. Rather, create a basic functional wardrobe utilizing the casual garments in the list and expand your wardrobe, emphasizing sport coats, sweaters, lightweight turtlenecks, and so on. Just keep in mind the parameters of taste, function, and quality.

Chapter 12

Creating a Wardrobe II:
Adding to the Basics

Most models maintain that as they change clothes during a photography session, they adopt different personalities. Each style, from business suit, to casual clothes, to tuxedo, has a distinct influence on the way the model acts and reacts. Naturally, it also changes the way he is perceived by the photographer.

The average man also finds that his personality is altered slightly depending on what he's wearing; if he knows he's dressed well, he carries himself a little taller, has more self-confidence. And there's no doubt that the people around him are affected by the fashion image he projects.

A lot of the Zoli men have, at one time or another, worked as a "fit model," for the major men's wear companies. These are usually very casual assignments where the model tries on a variety of garments so the designer or a company executive can see how they fit,

the way the colors blend together, and the manner in which the various components work as a whole. Sometimes, after a session with a fit model, a designer will alter his garments because he doesn't like the way things look, and other times he or an executive gets a new view of the way the line should be shown to the public. What, in effect, is happening is simply a very meticulous (and somewhat expensive) version of what most men do when they're out shopping for clothes or in the morning when they choose what they're going to wear to the office.

Now, not many (if any) men have models or designers available for consultations on how to put their wardrobes together. And it might even be counterproductive if they did. After all, the designer wants his clothes to be in the spotlight, and it's the model's job to act as a backdrop for the clothes. However, when a man dresses in the morning, he isn't (or at

least shouldn't be) attempting to show off his clothes, but himself. So, it's not a matter of putting the clothes together so *they* look good, but so *he* looks good. To this end, he needs to choose the garments appropriate for his body, look, and position.

But there is something to be learned from the editorials and advertisements in magazines of a designer's study of his clothes on a fit model. Although certainly not what the designer intended (more than likely they'd like you to mix and match *their* clothes in the same way they're displayed), you can get ideas on how to mix and match your clothes, choose new ones, and combine colors and fabrics to get the most use out of the clothes you have.

Top companies in the field of men's wear have learned over time that the way to sell a line is to first create the basic clothes that all men like and continually wear such as mock turtlenecks, solid cotton sweaters, and khaki pants, and then spice the collection up with a few more individual creations in which they experiment with unusual fabrics or designs. These individual garments can fall into the "great" category or the "awful" category . . . and it's up to the buyer to be able to tell the difference.

How do you know? Well, sometimes you just can't tell. But the following suggestions will help you decide on whether or not you need to add something new to your wardrobe.
• A fashion innovation is valid essentially when it has the potential to be a classic. Never buy anything new the first season it appears. Any fresh, different, or unusual garment that suddenly shows up in the shops, taking the fashion world by storm, can be just a one-season trend, appearing dated and "out-of-fashion" within a few months. If you buy it immediately you run the risk of wasting money. If you wait and the same thing shows up (no doubt in a slightly different version in order for the manufacturers to prove their worth) the following year and you still like the idea, then go ahead and add it to your closet.

• Be wary of buying anything "special." Now this is a double-edged sword. There is a theory that anyone who really cares about their clothes never buys anything that *isn't* special. However, the uniqueness of a well-dressed man's clothes comes from the fabric, fit, and design of his garments . . . not necessarily from the creator's stylistic innovations. To buy a particularly unusual sweater or a shirt with a distinctive design means that you run the risk of two problems: the first of which is simply that people look at the garment rather then you, which, as you already know, breaks one of the cardinal rules of the well-dressed man; and, if making an impression is important to you, wearing the garment more than once or twice around the same people can result in your friends pointing out that "you've got that shirt on again."

However, there are certain garments that the well-dressed man will find that he really likes; maybe a suede shirt, an alpaca sweater, a pair of distinctive tweed pants. These are not necessarily items that are required by the basic wardrobe list. But they are very handsome and masculine garments that, for the most part, fit nicely into any man's wardrobe.

When it comes to buying "special," keep your wits about you, and if you do decide to invest in a special garment, keep it low key. For example, chose a suede shirt in a neutral color (not red or bright blue or anything that vulgarizes the garment); the same goes for the alpaca sweater. The tweed pants could be coupled with more conservative garments, thus quieting their impact.
• Think about your wardrobe. The idea of suddenly purchasing a polyester orange-and-purple sweater (which is a ridiculous thought in the first place) and expecting it to fit into your wardrobe easily is not very intelligent. The point is to make life as simple as possible for yourself. So don't suddenly go crazy and buy ties or shirts, no matter how interesting they may appear in the store, unless you've got something to wear with them. Incidentally, if

you have clothes that work with that terrible sweater, please go back and read the preceding chapter.

• If you find something you really like and it fits well and looks great on you, buy more than one. Naturally, this suggestion doesn't include suits or overcoats (unless you have really big bucks), but since you're buying classically directed clothes, it can be both time-saving and economical to pick up extra shirts and casual pants, even dress pants, while you're shopping. Of course, even if two garments look exactly the same you always try on both of them. *Every* piece of clothing that comes from a manufacturer can have subtle differences that may alter their fit. There can also be tiny flaws that you don't notice unless you try on the gar-

ment. So don't make an attempt to save time and wind up wasting it by getting something you can't use after all.

• Remember what you do with your days and nights. Why would a man who only wears a tuxedo once every couple of years spend several hundred dollars on evening wear (when the right shirt alone can cost over a hundred dollars)? By the same token, if you wear suits a lot and rarely appear looking casual, you don't need several drawers full of sweat shirts. If you wear work clothes every day, you don't need a rack (usually a wire coat hanger) filled with neckties. (Families, please take note at gift time.)

• Keep in mind what you look like. Of course, by this point, you're working out, eating prop-

erly, and taking care of your body and skin, so chances are you're starting to look pretty good. But, if you still have a few pounds to lose, or have some other physical characteristic you're not wild about, then don't buy anything that will highlight these areas. (See Chapter 13, beginning page 103).

The point of the whole thing is not to waste money on items that will just gather dust and take up space. Choose wisely and think before you buy.

A FEW ABSOLUTES

The basic wardrobe collection is essentially a list of suggested items that are standards for the well-dressed man. It's possible to replace some of these items with others. However, there are some absolutes that the intelligent man always keeps in mind.

• Unless you graduated from a particular college (or at least attended it) don't wear that school's sweatshirt.

• Never wear gimmick T-shirts that say things. They're stupid.

• If a traditional designer makes a particular garment and has a well-known track record for this garment, then don't buy another manufacturer's version of that garment unless the alternate version is identical to the original and just happens to fit your body a little better.

• If you learn nothing else from this book, *never buy anything that's not made of natural fabrics.* Cotton, linen, silk, and wool are natural fabrics and are the appropriate materials for the man of style.

• Leave jewelry in the bank. And if it's not good enough to keep in the bank, throw it away. Men should wear a watch and a wedding ring (if they're married), plain gold or silver cuff links with the appropriate shirt, simple studs with formal shirts. That's it. If you own a special "something" that you insist on wearing on a chain around your neck, then at least keep the chain *under* your shirt. It should never show. Diamonds are not a man's stone . . . on anything, at any time, anywhere. In fact, there is no such thing as a man's stone. Keep wedding ring and watch plain and simple. If you feel the need to show people that you can afford expensive jewelry then you're better off wearing your bank balance on a small tag attached to your lapel rather than big jewelry. (Several years ago, one hopeful model went to an appointment wearing the latest Italian suit, pointed shoes, and pounds of jewelry. To this day, people are still talking— laughing—about his appearance, but few actually remember what *he* looked like.)

• Don't buy anything you plan to throw away. You won't do it. If you're caught on a business trip without your blue shirt, don't run to the nearest cheap store and buy a polyester version, rationalizing to yourself that it's only for this one day. You'll feel compelled to take it home, have it laundered, and more than likely wear it again and again. If you're missing something you need, buy it. And plan to keep it.

• Never buy anything just because it's on sale or you plan to fit into it in the future. If it doesn't fit either into your wardrobe or on your body now, forget it.

Chapter 13

Shopping

There's actually an art to shopping; finding the right things for your body and lifestyle requires some thought and experience. When it comes to going out and buying clothes, most men fall into one of three categories:

• He likes shopping and enjoys wandering about department stores. (This is a very rare male.)

• He hates shopping and won't go anywhere near a store, letting his wife or lover do all the work. (This man is more familiar to most people.)

• He doesn't like shopping, but cares about his appearance enough to make the effort. (This is probably the best situation.)

If you like to shop, the only thing you have to be careful of is buying too many things, which could result in accumulating some really terrible clothes simply because they happen to catch your eye at the moment.

If you abdicate your right of choice and leave it up to someone else, then all you can hope for is that they'll read this book.

The final category is, for the well-dressed man, the best. You go in and buy what you *need* and then get out before making any mistakes.

It may take a little time to learn and put into practice the principles of intelligent shopping, but in the long run the results are worth the effort.

To begin with, your first choice of shopping place should be what are usually thought of as "prestige" department stores. The reason is relatively simple. These stores carry the greatest selection from good designers, you should be able to return whatever you buy if necessary without problems, you will most likely be able to find your size in what you're looking for, the quality is most likely good, and the price is usually acceptable.

You may think that in order to really get the very best you're better off gong to a tiny, exclusive boutique or specialty shop. However, despite the fact that these stores do often have excellent clothes, their prices are almost inevitably higher than in department stores, the selection is sometimes limited, and you run the risk of coming up against one of those incredibly hostile and aloof salesmen who either have been trained for their job at a school for attack dogs or want you to think they're deposed royalty simply filling in time until they receive their rightful inheritance. Either way, they don't make shopping comfortable. So, unless you have a lot of money, are a standard size, and don't take bull from anyone, head for the department stores.

When you enter a department store and select the area you're looking for, go directly to the "reduced for clearance" counter. This is always the first place you should look for garments. Of course, there is the possibility of not finding anything suitable or running into a series of last season's trendy garments the store is anxious to get rid of, but you might find something useful.

It is also helpful to go to the sales at these stores. The turnover for major department stores is very great. They have to get rid of things as quickly as possible, so when they do have a sale, chances are the prices are compatible with cheaper places that have less merchandise. Sales at specialty stores can also be useful if you're looking for something in particular. But don't get trapped by the reductions on items that are overpriced in the first place. (A shirt that originally sold for $200 and is reduced to $150 is still a pretty expensive item.) However, if you catch specialty stores between seasons (and remember you never buy anything that only has a one-year use) then you might find some worthwhile bargains.

Buying at the end of a season is always a good bet. Since your clothes are always in style—the older they get the better they look —it doesn't matter that you're shopping at the end of one year for the next.

If you can't find a sale and need some shirts right away, then go shopping on a Monday, Tuesday, or Wednesday; the closer you get to the weekend the more hectic the activity and the less attention you get from sales people. Chose a sympathetic-looking salesperson and tell him/her what you want. Rumor has it there was a time when a sales staff knew all about their products. You really can't count on this situation anymore, so it's up to you to know the difference between cotton weights, quality, and so on. The following is a list of things to look for when you buy various garments. Included are the specifics of the most commonly used (and, incidentally, acceptable) fabrics for the clothes worn by men of style.

PURCHASING CHECKLIST

Regardless of what garment you're buying, there are certain procedures that should become second nature to you. These safeguards apply to jackets, suits, pants, shirts, ties, and everything else, and can help prevent you from investing your hard-earned money in shoddy materials or badly made garments. If you can't remember all the following precautions, copy the following list out and take it with you.

1. Gently tug on the seams of all garments (shirts, ties, suits, trousers, etc.) to make sure they are secure.

2. Always look for loose or hanging threads that can indicate shoddy workmanship.

3. Make sure buttons are securely in place and check to see if they are made of bone or plastic (plastic can break easily).

4. Check the stitching in overcoat, sport coat, and suit linings to see that the linings are firmly attached and won't hang out after one washing or dry cleaning.

5. On suits or sport jackets, crumple the fabric to see if it bounces right back (an indication of the quality of the fabric).

6. When buying pants make sure there is an extra button behind the fly area. This button will support the waist band and give you more security.

7. Keep your head when choosing the style of a new suit or blazer. Unusual colors or trendy lapel treatments can date the garment.

8. On all garments make sure the pattern matches in areas where two pieces of fabric are joined.

9. Look for shirts with a minimum of seven buttons down the front; the more buttons, the better the shirt will be secured in your pants.

10. Belts should have five holes, the actual length of the belt being measured from the center hole. If the belt has stitching or other detail, make sure it is well fixed.

Chapter 14

Dressing Your Body

Once you have the basics of shopping under your belt, it's time to take stock of just what styles, fabrics, and designs work best for your individual life, physique, and image.

This is a difficult area simply because it's so easy to slip into generic answers. But, in reality, there are a few fundamental facts that will help you direct (not necessarily limit) your clothes buying to its best and most productive results.

SUITS

The things you need when you buy a suit are the same shoes you'll be wearing with the garment (to make sure the pants length is correct), a belt (to hold the pants up correctly), a shirt of the same weight you'll be wearing under the suit (don't try to fit a suit over a sweater or heavy work shirt; it just won't

work), and a lot of patience. Suits are a major investment for most men. You don't wear a suit a few times and toss it out. A suit should last for years; as a matter of fact a good suit can seemingly go on forever. So don't think you can just rush in, grab something off the rack, and take it home. Suits require thought, consideration, and proper fitting.

When buying a suit, don't be locked into a particular size. Suits from different companies will fit you according to the way that particular manufacturer cuts his garments. Some designers create full suits, others design on a tighter line.

If you're tall and slender you can most likely wear suits with a European cut. These suits usually have a closer, more slender line with snug armholes and a jacket that slips in at the waist. Slender men can wear bulky materials, like tweeds, but should avoid any cloth that is too slimming as it can make them look gaunt.

Short, stocky people should really stick to American style suits. These suits have a more natural look, with sloping shoulders, a loose-fitting jacket and just generally more elbow room. Short men should avoid bulky tweeds or anything that shines. A subdued vertical stripe will add height and slenderness.

The number of buttons on a suit jacket are more than just a decoration consideration. A two-button suit can make you appear slimmer because of the V shape that is created by the drape of the lapels. Three- or four-button suits are best on slim men since they can make a heavy man appear to be "all buttoned into" the garment. A double-breasted suit can work on either slim men, giving them a stronger image, or a heavy man, camouflaging the excess weight. However, double-breasted suits rarely look good unbuttoned. So if in your work you tend to leave your jacket open, think twice about buying a double-breasted suit.

When trying on the jacket, the first thing you should turn your attention to is the collar. An incorrect fit in this area is an obvious indication that either the suit was bought in a cheap place or you didn't spend enough time getting it properly altered. The collar should lie flat against the back of your neck and upper shoulder, allowing about a quarter inch of the shirt collar to show. There is no alternative to correct collar placement and you have to make sure the tailor takes enough time to get it right.

Next button the jacket (top button on a two-button, middle button on a three-button, all buttons on a double-breasted) and sit down to see if the jacket pulls or appears to bulge. If it does, go back and get another size.

The correct length of the jacket is determined by the length of your arms. With your hands hanging loosely at your sides, curl your fingers. The bottom of the jacket should graze the cup made by your fingers. Jacket sleeves should allow one quarter inch of a properly fitted dress-shirt cuff to show.

Donald Charles Richardson

When fitting the pants, remove the jacket and put on your belt and the shoes you'll be wearing with the suit. The waist should be comfortably secure but not too tight. (You should be able to slip three fingers flat between the waistband and your shirt.)

Before the fitting actually starts, walk about in the pants, stoop, bend, get the pants to conform to your body, loosen up, and adjust to your physique.

If you are short and want to look taller, then don't have cuffs on the pants, rather have plain bottoms with a slight angle, leaving a little more fabric in the back than in the front. (This style is also helpful with bulky fabrics which tend to look strange with cuffs.) Men who prefer cuffs should have the pants even all the way around. With either cuffed or cuffless pants, there should be a slight break onto the shoe. If the break is too big, the pants can look sloppy.

If you choose a suit with a vest, check the fit of the vest by sitting in it to make sure it doesn't bulge or sag.

When you pick up the finished suit, try it on again. The store may not be delighted with this idea, but that's their problem. If you see anything wrong, insist that they fix it before you leave. Don't overlook small things like secure buttons, well-sewn zipper, and proper button alignment. There should be no loose threads resulting from the alterations.

Your basic suits should be navy or gray, either solid or with a subtle pinstripe. If you can afford several suits, then you might want to also buy green or brown suits. But if you need or can afford only a couple, you're better off sticking with the basic colors, with the exception of summer suits, which can be khaki or light-colored cotton. (Don't get carried away with this; it doesn't mean baby blue, just a slight salute to the warmer weather.)

The same proper fitting techniques should be employed when you're buying a blazer or sport coat with one addition. Before you let the tailor start work on the new jacket, take a

minute to remember your wardrobe and make sure the new jacket fits in with your other clothes, particularly trousers.

The basic sport coat is the navy blue blazer. Usually made of wool or wool blend (either light or heavy depending on your climate), it is

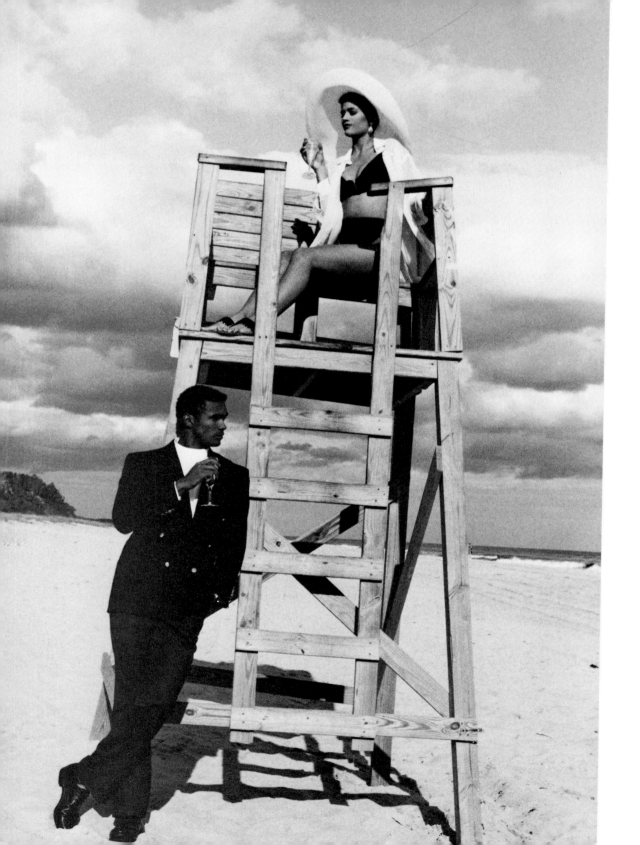

have worn them for a long time, you're always better off trying on the pants before you buy them.

Keep in mind that cotton pants (khakis, jeans, corduroys,) *shrink.* So shop accordingly, allowing for this peculiarity of the fabric.

Jeans can look good on almost everyone, provided they fit properly and have enough room in them. The same can be said of khakis. However, corduroys are not really a good idea for heavy individuals as the material can add

traditional and always correct. You can, once you own a blue blazer, invest in other sport jackets. But get the navy blazer first.

TROUSERS

Although the same methods should be used when buying dress pants that you use to buy the pants of a suit, casual pants can present other problems.

Of course, you check the trousers to make sure they're well made (see page 104) but the well-dressed man is as careful that his casual pants fit as he is that his dress trousers are correct . . . and this includes blue jeans.

Virtually every designer and manufacturer of men's pants has a different way of making them. Some create their pants with a very full cut, others make their pants with a slender cut, a few combine approaches, creating full-sized pants with tight waist bands. Even if you know a particular designer's approach and

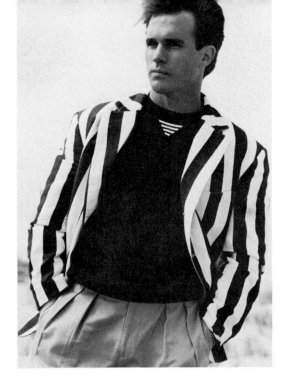

khaki, navy blue, gray, black, or a subtle tweed or check. Wild prints (such as those often seen on golf courses) are not a discussable topic.

SHIRTS

Dress shirts have to fit perfectly, otherwise all the effort you make when fitting a suit is wasted. So, for safety's sake, you should have your shirt size checked each time you shop for dress shirts. It doesn't matter that you haven't lost or gained weight, your body is constantly changing, and although admittedly it may not vary enough to cause your shirt size to change every time you buy a dress shirt, there's nothing wrong with making sure.

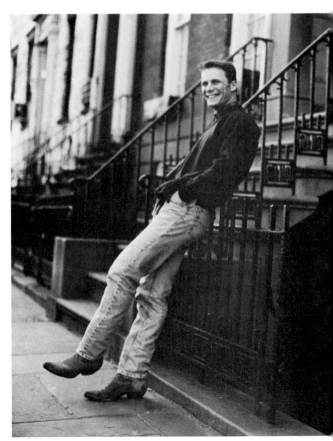

bulk and make an already big body look enormous.

Do not select pants with elastic waistbands or tabs on the sides. These details simply make you appear older.

Because casual pants have a tendency to shrink and chances are you'll be wearing them with a variety of shoes (including boots) you're better off having the length a little longer than for dress pants, which are dry cleaned.

In fact, it's generally better to give yourself a little extra room when it comes to casual pants. You might want to tuck in a sweater or just wear a T-shirt. The pants need to be versatile enough to handle these various requirements. *Always err on the side of looseness.* Although huge pants tightened with a belt may not be a great stylistic move, it's certainly better than having to suck in your gut in order to close the buttons. This does not mean that you should purchase "great big" garments (see Simple Solutions).

Dress pants should be gray, navy blue, black, or a subtle tweed. Casual pants can be

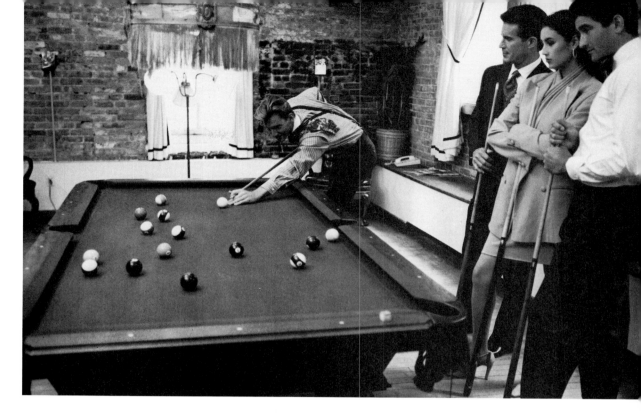

Again, keep in mind that dress shirts, for the most part, are made of cotton and subject to shrinkage. So buy accordingly.

The collar of the shirt should fit comfortably, not so tight it creates an impression on your neck, nor so loose it hangs away from your neck. (It is interesting—and a little frustrating—to note that in the past few years plastic surgeons have developed a new technique to remove the excess skin that accumulates under the neck. Although an operation of this type is not unusual for men who have a problem with sagging skin in this area due to age, the doctors have found they needed to find a new way of accomplishing the operation for younger men who wear their collars so tight they cause the skin in the neck area to be stretched. This is simply a case of doctors fulfilling a need that *never* should have arisen in the first place.)

The sleeve length of your shirt should be about five inches above your thumb, showing one quarter inch of the cuff when you have your jacket on. The cuff style is purely a personal decision, provided you make sure if you buy button cuffs (as opposed to French cuffs that require cuff links) there are two buttons,

collar you wear. For example, slender, European suits almost demand long, slender shirt points; by the same token, a full, American-cut suit doesn't look right with exaggeratedly long shirt points, although if you have a round face, you can select medium-long points slightly more than the traditional four-inch length.)

Tab collars are not a very important fashion invention. They're all right and essentially harmless unless you have a thick neck, in which case they'll give your neck the appearance of a sausage with a knot in it.

Choosing a casual shirt is less demanding. Of course, it should fit properly and be functional within your wardrobe. But where a dress shirt needs to fit properly under a suit, a casual shirt can be loose and comfortable, and, in fact, *should* be full. Denim or flannel shirts that are tight *look* uncomfortable and strange. And since these particular items should get better with lots of wear and age on them, you should buy them to feel and look good for a long time.

You might think that T-shirts are easy, but that's not necessarily true. As you already know, T-shirts that say things are essentially silly. There are some exceptions (as there are to virtually every rule), but they're few and far between. Basically, you want T-shirts you can wear either under your dress shirts and casual shirt, or on their own. The best for these purposes are made of good (usually thick) tightly woven cotton. They should have snug, well-knitted collars. White is the traditional color and, of course, you would never wear a colored T-shirt under a white shirt, but you can wear them with denim or sport shirts, or for that matter, on their own. Long-sleeved mock turtles (which bear a remarkable resemblance to long-sleeved T-shirts) are great for under blazers and sport coats.

Undershirts are fine under dress shirts provided they're either made like a regular T-shirt or a tank top. V-neck undershirts have no place in your wardrobe. They're sloppy, non-functional, and generally unattractive.

so you can fit the cuffs as well as possible. When it comes to shirt collars, things are more things to keep in mind.

The standard collar, which has points approximately four inches long (measured from collar tip to neckband) is the most classic and usual collar type. It looks good with virtually any suit or sport jacket. The button-down collar is a variation of this basic collar. And although button-downs are traditional, they are somewhat sportier than standard collars and shouldn't be worn with very dressy suits or for more dignified occasions.

Despite the fact that these are the "classic collars," that does not mean you're required to stick with them. In fact, with a little careful shopping, you can find collars that will help your face look its best.

Collars that have longer than four-inch points are excellent for men with heavy or round faces, tending to slenderize the face. Shorter-pointed shirt collars can make a thin face look fuller. (Note: The kind of suit you select also has an influence on the kind of shirt

SWEATERS

For a long time, all men's sweaters were made of wool, cashmere, or alpaca. And many of the best sweaters still are. There is, without a doubt, nothing that sets a man up better than a truly luxurious and indulgent alpaca or cashmere sweater.

But it is not mandatory to spend the money on these items unless you can afford it. Plain

cotton sweaters are great, as are the cotton/ linen or cotton/silk blend sweaters. They're also affordable, comfortable, easy to take care of, and can be very handsome.

A sweater is one of those things that can fall into the special category (see page 97) and occasionally there's nothing wrong with this kind of purchase. But the average guy will find that his sweaters will be more functional if they're solid colors such as navy blue or gray. Of course, some guys look great in bright blues, reds, and even yellows, but that doesn't mean they should have a unique design that dates them.

When it comes to fitting a sweater, make sure you have plenty of room. But keep in mind the material you're buying. Don't get an alpaca or cashmere sweater that's too big. They don't shrink unless you put them in the washer and dryer, which immediately screws up the weave. Cotton sweaters, on the other hand, if they're washable (and they'd better be since it doesn't make any sense to buy a cotton sweater you have to dry clean) will shrink in the wash. So buy accordingly.

Sweaters are usually small, medium, large, or extra-large. Some better sweaters are divided by chest sizes. If you like bulky sweaters, buy one size larger than your regular size.

Always try on a sweater at the store. Just as every designer has his own way of making pants, they also proportion sweaters differently. So check it out before buying.

Men who are heavy should avoid sweaters with a lot of cabling or detail which can make them look larger. They should also make sure the sweater isn't made too long. Although at first glance, the idea of extra length on a heavy man might make him think it'll be slimming, in reality, he won't pull it down to its full length, he'll pull it up to his waist. And the extra length will be gathered around his midsection, making him look enormous. Tall, slender men can pretty much wear whatever sweaters they like, provided the color and fit are right for their bodies.

Sweaters that you plan to wear under sport coats should fit a little closer to the body so they don't cause you to bulge out.

UNDERWEAR

Theoretically, this is one area where you can do what you please, unless you care what the people at the gym or your girlfriend thinks of what you wear under your clothes.

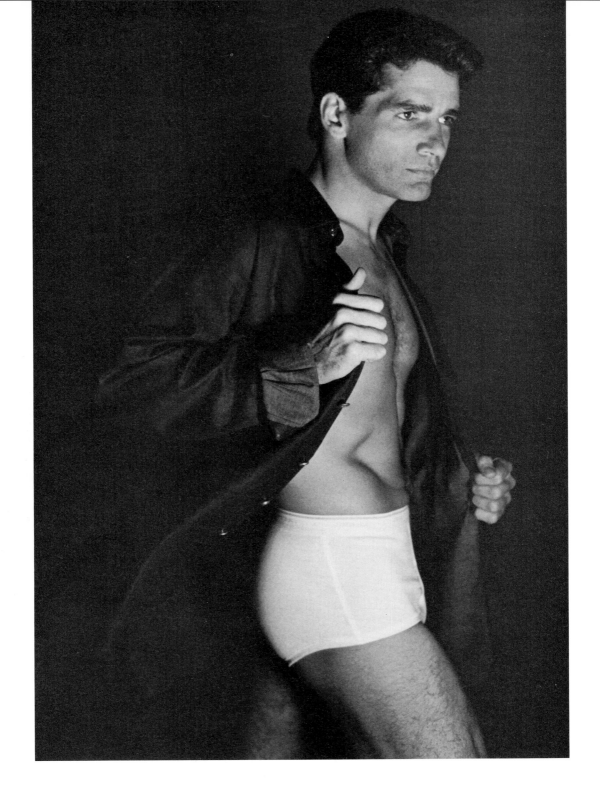

Donald Charles Richardson

Traditionally, a gentleman wears boxer shorts. And certainly, these are the most comfortable shorts for most men. However, although a well-dressed man's slacks are never tight, certain kinds of pants, like jeans, do sometimes fit snugly and may not be comfortable over boxers because of the extra material in these shorts.

The basic brief is still a standard for many men, and certainly they are the easiest shorts to keep neat and smooth.

When it comes to material, cotton is the norm. Keep in mind that cotton shrinks, so don't buy underwear too small. Periodically, silk underwear for men gains in popularity. This underwear certainly feels luxurious and it's a fun gift to get from someone special. But it is rarely practical since most silk underwear has to be dry cleaned. Sending your underwear to the dry cleaners is costly and falls under the heading of unnecessary expenditures. You're better off investing that money in more cotton underwear.

SOCKS

At the turn of the century, men indulged themselves in wild socks, mixing crazy colors and patterns. The Victorian males' affection for bright socks was probably due to the fact that most of the time they wore almost totally unrelieved black suits and high-topped shoes which, of course, covered the socks. When shoes came down, socks got more conservative. Over time they've periodically been loud and soft. Mostly they're a little bit of everything.

Socks can be made of cotton or wool, the more expensive from silk and even cashmere. Although many of the "sock rules" are now obsolete, there are still a few things you should keep in mind when selecting them.

Black socks should never be worn with brown casual shoes (such as penny loafers) or sneakers. By the same token, white socks are completely inappropriate with business suits or black shoes (except black casual shoes when worn with jeans or khakis). Socks for business wear should always go over the calf to avoid sections of your leg showing when you cross your legs. If you chose to wear socks with distinct prints or designs, make sure they have something in common with the rest of your clothes. This is not to suggest that your socks should match your tie or pocket handkerchief (one of the silliest fashion statements ever made), but the colors and textures should have some connection to the rest of what you're wearing. For example, if you choose a blue suit, red tie with a small yellow-figured pattern, blue-and-white striped shirt, and black shoes, then your socks can be plain

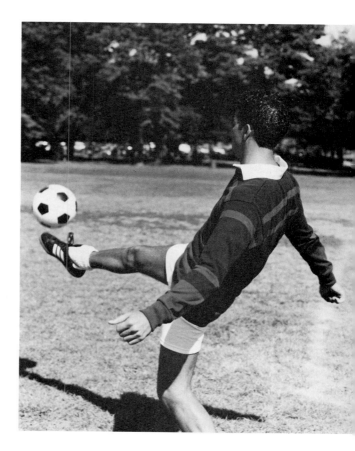

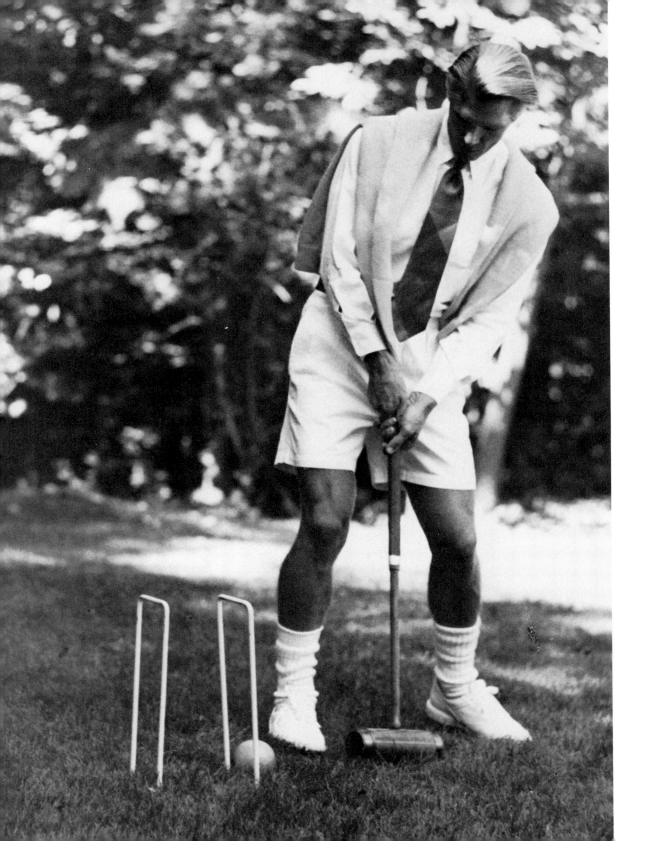

black, plain dark blue, or dark blue with a *small* red or yellow design. Obviously, green or orange socks are out of the question.

Correct fitting is important. If you buy cotton socks and they shrink too much, they can be very uncomfortable. Socks that are too large tend to bunch up and can cause blisters and irritation. Keep in mind the kind of material the socks are made of when you buy them.

TIES

Your necktie is one of the first things people see when they meet you. (Women particularly are, for the most part, at tie level.) And it can be the touch that absolutely makes the whole image come together or it can wreck the entire presentation.

Ties are generally made of silk, a few of wool. Polyester ties are both cheap-looking and, in the long run, very expensive since they ravel, wrinkle, and look bad very quickly.

When it comes to picking a pattern, it sometimes seems that there just aren't any limits. This is, of course, not true. Every once in a while (generally when the economic conditions are not at their best and men don't want to invest in new suits, so they buy ties to brighten up their business wardrobes) ties ex-

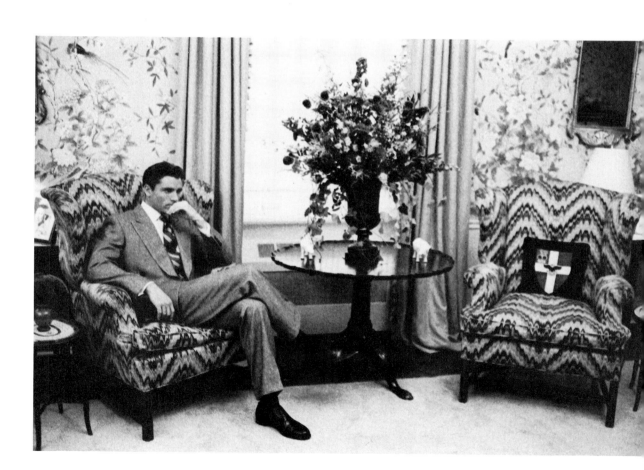

perience a big boom. During these times tie manufacturers experiment with an often startling assortment of patterns, colors, and designs, banking on intriguing the buyer.

However, a "unique" tie, just like a "special" sweater, can be a problem. It takes a great deal of taste and imagination to make unusual ties work with the normal businessman's wardrobe. You can't just grab one and throw it on. If you have the technique of combining interesting ties with your shirts and suits, that's great. Go for it. If you don't, then stick with the surefire designs such as simple repp stripes, subdued paisleys, and small figures in conservative colors. Of course, club and university ties are always acceptable (unless you belong to or have graduated from a peculiar place that has a vulgar or ridiculous emblem).

If you can afford it, there's nothing wrong with following the width-trend changes that periodically afflict this particular market. This does not mean that you should buy absurdly wide or narrow ties just because they happen to be the current gimmick. But going slightly wider or narrower as the times dictate is acceptable. However, it's really more intelligent to invest your money in a moderate-width tie that will not really ever go out of style.

Once knotted, a tie should fall dead center, just touching the top of your belt buckle—no longer, no shorter. Many men complain that getting the tie to fall properly is very difficult, and it's possible that the fault may not lie in your inability to tie the knot correctly at the right place but in the tie itself.

Ties range in length from fifty-four to fifty-eight inches. This can make a big difference, naturally, depending on your height, in how far down they hang. Also, it's possible that a tie is not necessarily made even; that is, the stitching inside the tie is not absolutely even, which can result in the tie's falling slightly off center. There are ways of making sure you don't get a tie that doesn't work for you.

The easiest way of selecting the right length

tie is simply to take along one that fits you when you shop. Lay the new tie on top of the old. If it's longer or shorter, don't buy it. (You could also measure a tie that fits well and take the tape measure along, but that's a lot more trouble.) To make sure the tie is made properly and will fall correctly, hold the it in the middle over your hand and let the two ends fall. The small end of the tie should fall directly in the center of the large end. If it doesn't, it means the stitching is off and the tie will not fall properly down your shirt front.

Just as the width and length of your collar points can influence the way your face looks, so can the knot in your necktie. The knot itself is purely a personal choice, but final result should have a small dimple in the center, the sides even and neat. And the width of the knot should be influenced by the width and appearance of your face. Wider knots can make your face appear wider, narrower knots are good for full-faced individuals who want to look

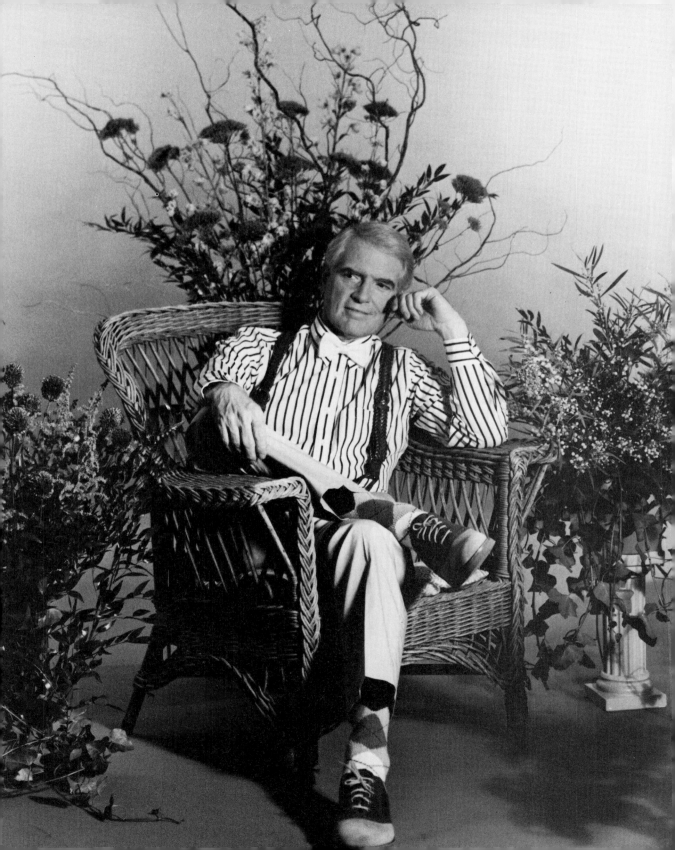

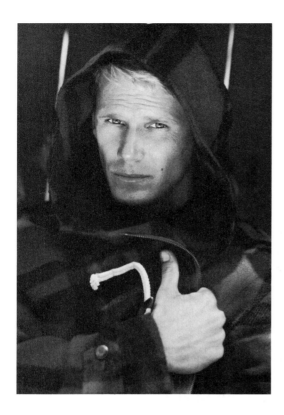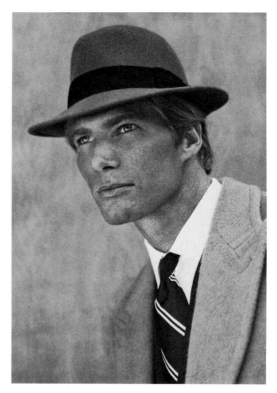

slimmer. The knot should cover the top shirt button, lying firmly but not tightly, against the neck.

Bow ties are periodically popular, and some men wear them all the time. (Unfortunately, the wrong men often choose bow ties as their fashion statement. If you have a chubby neck avoid bow ties, which will just make you look heftier.) If you can and do like to wear bow ties, do it right. Actually tying a bow tie isn't all that difficult, it just takes a little time to get the hang of the whole thing. A clip-on bow tie is totally out of the question for any man who really pays attention to his clothes.

OUTERWEAR

For the basics, a man needs three pieces of outerwear: an overcoat, a trench coat, and a

jacket. But there are a lot of variations within this narrow framework.

Overcoats, to be completely functional, should be black, navy blue, or camel. They should be made of wool, cashmere, or camel's hair (which is actually wool) and fit loosely, but not so full that they make you look like you're wearing a pup tent in heavy wind. The sleeves of an overcoat should extend slightly below your shirt sleeves and the bottom of the garment should reach below your knees. (Short men will look best if the coat covers the knee—tall men can buy even longer coats.)

The style of the coat is important. Like a suit, chances are you'll have this garment for a long time, so don't buy anything too trendy or "special." A simple single-breasted overcoat without a belt or other attachments (which can get lost and thus leave you hanging) is most likely best. And it's usually wise to

avoid a coat that is fitted at the waist as, if you put on a little weight or wear a bulky suit, it might appear to be too tight.

The classic of raincoats is the trench coat. With gunflaps, belts, epaulets, and wrist bands, this is one time (perhaps the only time) where all the extras are actually an addition to a garment. A good trench coat should be beige or tan and made of good quality woven cotton. It should fit the same way you fit an overcoat.

If you don't like all the stuff on the traditional trench, then a simple khaki single-breasted raincoat is just as good (but you may never feel like Humphrey Bogart). Incidentally, if you live in a cold climate, getting a raincoat with a zip-out lining is a good idea. Make sure the lining fabric is well made, the zipper attachment is firmly attached and doesn't stick. (On a good coat the zipper will be covered by a strip of material so it doesn't

show when the lining is removed.) Also, when you have the coat cleaned, remove the lining and have it cleaned separately.

When it comes to jackets, men have a very wide range of choices. There are jean jackets, duffle jackets, bomber jackets, baseball jackets, jackets made of cotton, wool, and nylon. Essentially, you want a jacket that will work with as many different looks as possible.

Some of the best jackets are those that are inspired by work clothes. Denim jackets, wool bombers, and hooded parkas are all great. It all depends on your life-style and your body.

Short heavy men are better off in longer casual coats. Short slim men will most likely want to wear short jackets. Tall heavy men should wear mid-length coats, and tall slender men can pretty much wear whatever looks good on them. But that's the point. This is a difficult item to shop for simply because you

have to be very choosy and look at all aspects of your appearance in the jacket . . . if you want it to do a great job for you.

The one thing about jackets that's pretty universal is that they should be big, cut full and open for maximum freedom and comfort. They should not make your butt look big or shorten your body. Check the way the collar fits around your face. Few men pay much attention to this, but if you wrap a scarf around your neck and close up the jacket you can create a great look . . . provided the collar is flattering to you. Hoods can also be very flattering, creating a great frame for the face. Of course it all depends on the hood and the face. But that's both the difficulty and the beauty of a great jacket. It can be uniquely you, provided you take the time to shop carefully.

HATS AND CAPS

Although not every man wears a hat anymore, there are times when head covering is both attractive and functional. Besides, some men just like hats.

Today's basic business hat has about a two-inch brim which is usually "snapped" down in the front and up in the back. These hats are most often made of felt with a silk band. The crown can be pinched together in the front or there can be a crease down the center. Black or gray are the most appropriate colors although brown is now also an acceptable color for business hats.

Caps are great. Stocking caps or baseball caps are both fun and comfortable, as well as helpful in keeping heat in the body on very cold days. Remember that stocking caps need to be cleaned just like any other knit item of apparel. Baseball caps are harder to clean. So if you have one that starts to get too grungy you might have to toss it out or save it for wearing only when you're playing sports.

The most important rule about hats is to know when to take them off. Never wear a hat during a religious ceremony (unless your observances require them), indoors at any time, or during the playing of any country's national anthem.

GLOVES

At one time no gentleman would ever think about removing his gloves before shaking hands. Today, if a man shakes hands while wearing gloves (outside during a blizzard for example) he feels compelled to apologize. Times change. But good gloves have essentially remained the same. The best still have three lines on the back and they're made of pigskin, deerskin, calf, or very fine cowhide. They should fit very tightly, which makes them both functional and neat-looking. Leather stretches; consequently, it is important that the gloves are a snug fit at the start or they'll start looking ragged (and letting in cold air) in a short time.

If you're combatting very chill temperatures, you might choose to wear gloves lined with shearling or a fur of some sort. This does not mean that the glove shouldn't still fit well.

Big bulky gloves are only acceptable for sports or outdoor work and have no business in the office . . . any more than mittens or yarn gloves do. Gloves with fur on the outside are both nonfunctional and silly.

To keep gloves looking their best, shake them out after removing to smooth out creases, then store them flat.

A Word About Animal Hides Fur and leather for men are touchy subjects. If you're an animal lover, chances are you don't own garments made from either of these materials. If you're neutral, you might have a leather jacket. Some men don't mind wearing fur. If you do choose to wear a fur or leather garment, there are some tasteful tips to keep in mind.

Fur coats on men are really questionable. They're just too much, particularly when worn

on a short or heavy man; it gives the appearance of a fuzzy little mound moving down the street. Even on a tall, great-looking guy, a fur coat is almost immediately the first thing someone sees when they look at him. And that is, of course, a no-no.

Fur jackets might be all right provided the fur is on the *inside* of the garment. Why anyone would want fur on the outside is an unanswerable question. Obviously, if the jacket is for warmth, it's going to be a lot more effective if the fur is on the inside. If the jacket is just to show off, then you shouldn't be buying it in the first place.

The same length suggestions apply to leather garments. Leather coats, regardless of how elegant, beautifully cut, and expensive they are, have a tendency to have just too much leather.

Leather jackets are great, particularly if they're old and a little beat up. Keep in mind that regardless of what colors your local leather store might be pushing, leather jackets are brown or black. No man of style, or even one with any sense, would invest in a blue, green, or red leather jacket.

BELTS

This is actually very simple. Leather belts are brown or black. A belt that you plan to wear with a suit or sport coat and slacks, should be darker than the material of the other garments. It can be a lighter shade when worn with jeans or sport clothes. Webbed belts (for wear with shorts and casual pants in the summer months) can have color. No well-dressed man owns a vinyl or white belt. Belts and belt buckles for business are narrow and unobtrusive, although wider belts with more creative buckles are all right for jeans and casual pants. This does not mean, however, that a well-dressed man wears a chunky cheap (or expensive for that matter) belt buckle with his name in raised script or a map of his home state in tedious detail.

Belts usually have five holes, the center hole being the one the measurement is based on. You should buy casual belts a little larger than you do dress belts since you might opt to wear heavy shirts or sweaters tucked in.

Heavy men should avoid wide, heavy belts, as they simply add more size to the waistline.

SUSPENDERS

Suspenders (braces if you're really dignified) are not only a trademark of the "classic gentleman," they also are very functional, masculine, and handsome. Really fine suit trousers are made for button-on suspenders. If your suit isn't adequately supplied with suspender buttons, wear a belt. You can, however, wear the snap-on variety with jeans or khakis.

Suspenders can also be fun. Since they are usually completely hidden (unlike socks,

which can be seen everytime you cross your legs) you can go a little wild. Get suspenders with animal motifs, maybe pictures of bathing beauties . . . enjoy them. Just don't get suspenders that match your tie or socks. That's another one of those gimmicky things best left at the discount stores.

SHOES

When you consider that seventy percent of the body's bones are in the feet, it makes sense that the proper shoes are one of the most important purchases you'll make. Although for many items of clothing it's simpler to just suggest buying the best, some of the most expensive shoe manufacturers make some of the ugliest and least supportive foot wear. While this doesn't mean that inexpensive shoes are the answer (some of them are even worse both on and for your feet), it does mean that shoe selection is not an easy task.

Shoe styles vary, but a rule of thumb is quite simply, don't buy a shoe that has anything on it you have to take care of separately from the shoe itself. This includes tassels, buckles, metal details, and suede patches. Keep shoes simple and easy to maintain because regardless of how well the shoe fits, if it looks sloppy or shabby it's a bad investment.

However, just because you've bought a simple, straightforward, handsome shoe, don't think your work is finished. Virtually every

man has a grandmother who has said that you can always tell a gentleman by his fingernails and his shoes. Unpolished shoes with run-over heels are offensive and even (perhaps particularly) when worn with the best suit, shirt, and tie money can buy, are indicative of an individual who doesn't follow through.

Interestingly enough, a lot of men don't like black shoes. They rarely have a reason, they just don't like them. Chances are their dislike stems from having small feet. Most men like their feet to look not big but at least strong. Men with small feet may find that black shoes make their feet look smaller. The only way of getting around this situation is to buy only suits and other clothes that are wearable with brown shoes. However, you have no choice when it comes to formal wear; black is the only acceptable color for the shoes you wear with a tuxedo.

To get the right shoe size, always shop for shoes late in the day. Your feet will swell as the day progresses and if you shop first thing in the morning, you're going to wind up with a pair of shoes that are not comfortable later in the day. Also, always wear the correct socks when shopping for shoes; dress socks for dress shoes, athletic socks for sneakers. If you're buying a pair of shoes you don't plan to wear socks with, such as casual loafers for summertime, and the shoe store won't let you try on the shoes without socks, then wear silk socks for the fitting. They're usually the thinnest type.

A well-dressed man has leather heels on his shoes. Rubber ones last longer, but they don't look nearly as good. It's worth the expense to have to have the shoes reheeled.

Cowboy boots have become a standard shoe, wearable with a variety of clothes. However, they are still not really acceptable with a business suit in a conservative office, nor are they appropriate for formal wear. As with regular shoes, less is better. Leave off the doodads and fancy touches. A cowboy boot is quite enough on its own without being added

to. Also, it's a good idea to avoid the really high heels unless you want to appear as if you're walking at an angle with your butt in the air.

Although many men consider cowboy boots the most comfortable foot wear there is, it can take a while to get used to them. To break in a pair of cowboy boots so they last and you don't hurt your feet, wear them only an hour or so the first time, extending the period until you and the boot are used to each other.

Sneakers are sneakers. Unless you're involved in a sport that requires a special kind of shoe or one with a particular support system, there's no reason to invest massive amounts of money in them. Try them on with sweat socks, choose a pair with plenty of room for your foot to expand, yet snug enough around the top to keep the shoe firmly in place. Avoid any sneaker that's "heavy," and clean them often.

NIGHTWEAR

You're probably better off sleeping in the nude, giving your body a chance to breathe. But if you prefer covering up under the sheets, you have essentially four choices: your underwear, sweat clothes, a night shirt, or pajamas.

Underwear is out. Aside from the fact that it's just sort of tacky, remember, you showered as soon as you got home. And surely you wouldn't put back on the same underwear you wore all day. Would you? No.

Sweat clothes can be very comfortable. It all depends on who you're trying to impress.

Chances are the workout wear you choose to sleep in is old and well worn. As long as it's clean and you're not trying to be chic, relax and enjoy them.

Few men wear night shirts. These garments, if large enough, can be very comfortable, although they have a tendency to ride up. You might find that that movement makes your time in bed more interesting. However, if it's sleep you're after, you'll probably be more content with pajamas.

Pajamas are the traditional sleeping suit. The majority of them come with a button jacket and pants that either tie or have buttons with loose-fitting legs. These are perfectly acceptable for most men, but pajamas have changed slightly over time and you can most likely find pj's with knit cuffs and bottoms. These help keep the pajamas from riding around your body and are also warmer in cold weather.

Of course, pajamas should be made of cotton, which breathes easily, or silk (if you happen to have a lot of extra money). However, chances are you won't be comfortable in silk pajamas in the summertime simply because

the material doesn't breathe and consequently can be very warm.

Bathrobes should be as big as possible. When you're getting out of the shower or just curling up with a good book, all that extra ma-

terial is physically comfortable and emotionally comforting.

For the most part men's bathrobes stop at the knee. This doesn't make a lot of sense. After all, if you've just had a bath, your legs

Donald Charles Richardson

are going to be chilly too. So get a long robe, one that reaches your feet. It'll be a lot more functional.

Cotton is the best material for robes. And although a white terry robe is the usual standard, if you're messy get the robe in dark blue or brown. It won't show the dirt so easily. Silk robes are elegant, as are silk smoking jackets. But, in reality, both these garments are something of a waste of money and a little affected, particularly if your life-style doesn't include midnight champagne suppers.

A Word About Tuxedos Despite the fact that over the past few years manufacturers have managed to make tuxedos from an astonishing range of fabrics and colors, basic black, or possibly midnight blue, are still the only colors a man of style would choose for his formal wear. And his shirts are pleated, solid white; they don't have ruffles, edging, lace . . . or anything else.

Bow ties are also basically still black, as are cummerbunds. It's sometimes acceptable to wear a tie/cummerbund combination of another color. However, discretion is advised, and if you're not sure of what you're doing, stick to black. Cummerbunds are worn with the pleats facing up (as they were originally designed to catch crumbs). Shoes must be plain black.

If you wear a flower in your jacket lapel it should stand alone. A rose is preferable, another simple flower is acceptable, so long as it doesn't have anything stuck around it like ferns or other flowers. If a rose isn't enough by itself, the whole discussion of style is pointless.

This is one of those areas where personal fashion statements *must* be left at home. The only statement you want to make with your tuxedo is that you're a gentleman and you know how to dress properly for an important occasion.

A Word About Maintenance Naturally, your clothes are clean and neat. It doesn't matter how much you invest in your wardrobe, or how perfectly everything fits, if the garments are soiled, wrinkled, or badly cared for.

If you send your laundry out, use a prewash product on spots as well as on the collars, underarms, and cuffs of all shirts.

Before sending out laundry or dry cleaning,

make sure all the buttons are snug, there are no loose threads, and linings are secure. If you need repairs, either point them out to the cleaner or do them yourself before taking the clothes in. Chances are, once the garments are back, you'll forget about the problems until you're ready to wear them.

Always run a lint brush or piece of tape over the shoulders and front of a suit and the shoulders, back, arms, bottom, and *inside* the lapels of an overcoat before you leave home. Lint and debris hide in these places.

Shoes must be polished regularly. Keep in mind that you don't have to glop on the shoe polish. It only takes a little bit. Shoe polish that isn't buffed or brushed off will dry in the crevices of the shoe and rub off on the bottom of your pants making both look terrible. Of course, you have the heels replaced when they start to look run-over. Shoe trees are a must.

Sweaters are never hung up. Fold them for storage.

The care and maintenance of your wardrobe is, like the rest of your personal appearance program, essentially common sense. If good clothes get the attention they deserve they'll last for years.

Simple Solutions

■ One of the biggest mistakes heavy men make when buying clothes is selecting oversized garments in the largest size available. In reality, if a large man is wearing a large garment in the largest size, he will simply look larger. If he can wear a medium oversized shirt, jacket, or pants, then that's what he should buy. The oversized cut of the garment will give him the room he needs while reducing the amount of voluminous fabric around him. By the same token, a thin man who wears very slender clothes runs the risk of looking even thinner.

■ Although the rule that heavy men should wear dark colors is still adhered to by a lot of guys, it's not the colors that make the difference nearly as much as the fabric of the clothes. If a heavy man wears a heavy fabric, he'll look heavier. Instead of tweeds and bulky wools, the heavy man can choose smooth-surfaced wools or gabardines.

■ When packing for a business trip limit yourself to three colors. Do not pack a "special" suit with its tie, socks, and shirt and then another "special" and on and on. You want your clothes to work together to give you a range of outfits without carting around a lot of luggage. Choose, for example, blue, gray, and white. White or blue shirts will work with blue or gray suits; if you soil the blue pants, you can wear the gray pants with the blue jacket. Ties and socks should also be compatible with everything else you're taking.

■ Save your old sweat socks. Even if they have holes and are tattered around the tops, they're great for buffing shoes. They are also handy for

packing shoes. Just slip the old sock over the shoe and you'll keep the shoe and the surrounding clothes clean.

■ When you're shopping, never think about where you are socially and professionally, but about where you want to be. Picture yourself in the job and life-style you want and direct your wardrobe toward that goal.

Industrial-Strength Endeavors

■ Even if you take excellent care of your shoes, you may, over time, notice that the polish is building up, clogging the seams, and making your shoes look dirty right after you've cleaned them. The answer is to give your shoes a bath.

Good full-leather shoes can be washed. Don't, however, try this process with suede, plastic, or cheap leather foot wear.

To complete this routine, remove the laces and submerge the shoes in a sink with soapy water. Using a sponge, scrub the shoes, removing old polish and dirt (making sure not to neglect the soles). Once the shoes are clean, empty the water from inside and blot off excess water. Wrap the shoes in newspaper, and set the shoes aside in a cool place to dry overnight. The next morning, remove the newspaper, put in shoe trees and return the shoes to a cool, dry place until they're completely dry. Then treat the shoes with saddle soap to soften the leather and polish as usual.

PART V

It's Your Turn

The man who doesn't get it together usually has what he considers valid reasons. He's too busy, can't afford it, doesn't want to be bothered, or has no idea where to start.

The fact of the matter is, if you do have lots of reasons for not taking care of yourself, then chances are there's only one real reason . . . you don't want to. That's your business. So be it.

But if a small voice inside you is urging you to at least make a start, then perhaps this is the time to exert a little effort.

Hair, skin, physical conditioning, taste, and style are all it's about. And any man can clearly learn and develop these elements and put them together in a total package.

Chapter 15

Taking Control

If you've read this far you're either encouraged about what you can do about yourself or discouraged, viewing the whole thing as just too much work, effort, and time . . . so it's time to make a decision.

The bottom line here is that the way you look involves making choices, just like every other aspect of your life. If you don't look your best, don't try to slough off the blame. There's no question that the condition you're in is most likely of your own making. If you don't look good, it's your own fault. You can't blame it on lack of money or too much work.

It is all within your power and control. And when you consider that your body is one of the few things you can actually fully manage and direct (while careers and social lives, for example, by their very nature require input from others), it seems strange that you wouldn't choose to exercise complete control.

Going to the gym, shopping for the right clothes, getting a good haircut are all invigorating and energizing accomplishments . . . small victories over the chaos and confusion in which most modern individuals live. And they all contribute to living well.

Being sure . . . always positive that you look "right." That no one around you, regardless of how rich, handsome, charming, popular, or important they might be, looks better than you do, simply because you've taken your own personal presentation to its highest level. Since one definition of perfection might be "taking anything to its ultimate," you're perfect.

Essentially, there really aren't any ugly people. There are stubborn, ignorant, lazy, and disinterested people . . . but no ugly ones.

If you're sitting at home, simply doing nothing, or feeling that you invest a lot of time in your appearance without getting the full return on your investment, then obviously

you're doing something wrong. Some people assume that good taste is something you're either born with or not. And that to have good taste you have to have money. Both of these assumptions are just not true. You don't have to be rich or blessed with perfect parents in order to look good, you just have to work at it.

The models in this book are often held up as some sort of "ideal" men. But if you take away the things that don't truly affect your appearance—height (which really doesn't matter), perfect features (which not all models have), and the ability to look good in front of a camera (which few men actually need)—then the differences between you and them are probably not that great. Certainly not too great to be overcome.

But for every benefit, there is almost always some sacrifice. And it's the same when it comes to looking good. In order to get your body into shape, you may have to give up fattening foods, leave the television long enough to work out, use the money you had planned for a trip to pay your health club membership. There is no such thing as a free ride. And anyone who tells you that you can have a great body without a proper diet, exercising, and taking care of yourself is flatly lying. All those quick-fix books primarily only fix the bank accounts of the authors. It takes work. But if you decide it's worth it, the results can be amazing.

A Word About Embarrassment Although more and more men are now comfortable with paying attention to their clothes and getting the right haircut, when it comes to a lot of the grooming and self-care procedures available to them, they're still somewhat intimidated and self-conscious. This is an awkward situation, particularly when you consider that chances are the way you presently look is the result of the way your friends and coworkers look, perhaps the way your girlfriend or wife wants you to look. And it's particularly rough when it comes to rising above the way you have always felt about yourself.

If you've been one of the boys—heavy, messy, and generally unconcerned with your appearance—and you want to start looking better, then there's a chance you're going to get some heat. But you might also get a promotion, a date with someone the other guys can't get near, and, at the very least, you'll gain in self-confidence. It's a tough thing to accept, but the people you're around want you to be and stay the way you are. They know you, they're comfortable with you. If you become someone else, then they have to take the trouble of learning about you all over again. But it's a lot better to take the chance and be everything you can be than sit back, let life slip by, and think in old age that it would have been nice to have tried.

A Word About Age Perhaps the easiest excuse to continue doing nothing about your personal appearance is a feeling that you're too old. Good looks belong to the young. Nonsense. Young people look good simply because youth has its own freshness and beauty. That hardly means they're taking care of themselves. It has been shown in scientific studies that a man in his nineties who works out can actually build muscle and can be in better shape than a man of fifty who does nothing. Obviously, if age isn't a barrier to fitness—the most difficult part of looking good—the rest of it should be very easy.

Besides, the mature man has an edge. Older men who are in good shape, dress well, and keep it together, are considerably more elegant and dignified than their youthful counterparts. And it's not just because they're more experienced; that old chestnut is true but few men rely on it for emotional support. Mature men have an advantage for several reasons. Their bone structure has settled down, establishing the contours of the face. The body chemistry is under control, less likely to cause skin eruptions and sudden bursts of hormones that can wreak havoc with the body. Finally, and most importantly, mature men have be-

come centered, displaying none of the self-consciousness that causes awkwardness.

Think of your personal appearance as a work of art. As it reaches maturity it is refined, sharpened, and brought to full completion. There's no such thing as age being a deterrent to looking good. So let's not hear any more about it.

Chapter 16

The Game Plan

One of the most important parts of every endeavor is the attitude and commitment with which you go into it. And if you've decided to "get it together," then you have to figure out the best way of making sure you follow through.

Of course, if you're really committed, then there's no problem. But for the man who's tried every diet, joined several gyms and only showed up the first week of his membership to work out, buys skin-care products and leaves them on the shelf, there are a variety of "placements" that can come in handy. For example:

• View self-care as a part of your business. For the workaholic who rarely has time for anything but business, giving attention to his personal appearance within the framework of his job makes it almost impossible for him to cop out. To manage this routine, he simply puts exercise, haircuts, even adequate shaving time in his schedule . . . and like all his other appointments, he religiously adheres to them.

• In this increasingly chaotic world, most men cherish their private moments. They don't get them often, surrounded as they are by business associates, family, friends. But there's no question that the guy who manages a little time on his own every day is usually a happier person. Well, getting a haircut obviously requires at least one other person (and in some of the more chic salons, a whole platoon of people whose purpose no one has ever discovered), but you can go to the gym. Although there are people around you, you don't have to really communicate with them (and in fact it's a lot better if you don't. It's rare that you have someone with you in the shower, and shaving is certainly a solitary pursuit. Stretch out these basic grooming procedures, making sure you scrub your face well and shave carefully. You don't have to concentrate on doing

Donald Charles Richardson

either of these; instead, let your mind wander, considering how you'd run the country if suddenly elected president or what you'd say to the press if you'd just scored the winning touchdown at the Super Bowl. Make taking care of yourself something you look forward to because these times are yours.

• If you are by nature self-centered (and chances are you know if you are) and indulge yourself by not taking care of your body and looks, then it's time to reverse the program. Of course, one mistake that self-centered people make when they do virtually anything is talking about it. Publicly announcing all the details of your self-care program may cause the people around you to call you an egomaniac, so don't say anything. Keep the whole thing a secret and then, as you start to really look good, you'll have something to be proud of. And you won't have to blow your own horn —everybody else will do it for you. This way you can stay as self-centered as you want without having to let everybody else know how shallow you really are.

• One of the first things a doctor usually tells an overworked executive is "Get a hobby." He might suggest stamp collecting, bird watching, or ship-in-a-bottle building, none of which are likely to interest the guy at first. But it's astonishing how involved even the most disinterested man can get in the strangest avocations. Why not make self-care your hobby? There's all kinds of things you can find to take your mind off the job and relax you: different exercise methods, searching for interesting healthful foods, experimenting with some of the Industrial Strength skin-care procedures . . . whatever. There is just as good a chance that self-care can be as absorbing and as interesting as stamp collecting. And if you really do take care of yourself maybe your doctor will leave you alone.

• Survival can make you stronger. Although most men periodically envy (and perhaps resent) the guys who always look great, the man who isn't in good shape and has perhaps spent a lot of years never looking very good who starts to reverse his image will discover an astonishing amount of energy and strength from the process. It is almost impossible to describe the feeling of power that comes over the man who finds himself finally in charge of his body and his appearance and experiences the gradual, increasingly rapid, positive changes. He is running the show; the impetus carries over into virtually every aspect of his life. And it feels wonderful.

• Do it because you care about yourself. Regardless of how great a guy you are, how bright, intelligent, affectionate, or successful, your friends and business associates will still have a little nagging doubt in their minds that you truly are interested and concerned about yourself in you don't do anything to help yourself look your best.

There are a lot of men out there who *do* take care of themselves and look sharp. These guys don't really care whether you're in shape or not; in fact the worse you look, the better they appear. If you really think of yourself as a valuable and productive person, then you won't let the other guy win out just because he spent a little more time at the gym. If you really care—if you truly *like* you—you won't forget yourself.

A Word About Taking Care of Yourself The focus of this book has been on the things you can do to make yourself look and feel better. Perhaps, regardless of all the coaxing and encouragement, you still don't feel ready to really make a commitment to changing your basic disinterest in working out, taking care of your skin, and dressing well. However, even if you don't choose to take matters in hand and make positive efforts toward your personal appearance then at least promise yourself you'll stop doing things that actually sabotage you. *Don't* eat the greasy food or wear the same socks several days in a row—you know

the kind of stuff. In general, you just might be a little kinder to your body. It'll appreciate it.

Most likely the primary reaction to anyone advising a man to take better care of his skin and hair, and pay more attention to his wardrobe is simply, "I don't have time for that crap." The only answer is that it doesn't take that long once you have it all under control.

Maintenance is considerably easier than creation. Once you have a slim, trim body, your skin is in good shape, and you've accumulated the right wardrobe, it doesn't take any longer to look good than it did to look bad. After all, essentially you're doing the same things: showering, shaving, washing your face, getting haircuts, trimming your nails, dressing. The only difference is you're doing it right. (All right, if you're not in a regular workout program and you start one, as you should, then that does add another facet to your day.)

There's no way anyone can convince an individual to do *anything*. People will usually pretty much do what they want. All the good advice in the world means nothing if you, as an independent person, aren't ready or willing to get to it. So the decision is up to you.

However, if you really do make the effort, it's absolutely impossible to fail. Every time you exercise, shave carefully, polish your shoes, or choose the right shirt and tie, you're taking a step in the right direction. And, if nothing else, always keep in mind as you work on yourself that you're an individual. Don't fall for any quick-fix cures, generic disciplines, or sure-fire answers. Choose wisely.

There's no reason every man can't be a man of style. Good luck.

Credits

THE MODELS

Men
Mick Baker
Jerry Barnes
James Beeler
Mark Bruhn
Mathew Buckham
Michael Butler
Ian Carney
Patrick Collis
John Conroy
James Coulter
Leon Craig
Mike Dale
Paul Davis
Rick Dean
Ellis Smith
Billy Gleason
Kevin Gouche
John Healey
John Hoffmeister
Carl Holmes
Leo Hunt
Ingo
Matt Jennings
Earl Johnson
Mark Judge
David Kaptein

Terrance Kava
John Kelly
David Kile
Roger Krahl
Kadri Kurgen
Doug Lavell
Randy Lee
Craig Linden
Loic
Adrian McCourt
Joey McGilberry
Matt McGuire
Rafael Mena
John O'Leary
Kyle Pagach
Robert Cole Pagliaroni
Brian Quern
Todd Rafa'l
Tom Rafa'l
Rob Simonson
Craig Smith
Joe Smith
Tony Stephano
Randy Taft
Michael Tardio
Tom Tripodi
Joe Ulam
Pat Vairo
John Vento

Wade Caughman
Walnei
Scott Wilke
Allen Williams
Charles Winslow
Doug Yates

Women (also from the Zoli Agency)
Geri Gongora
Martina Jeansson
Kira
Uschi

Children
Emma Kaptein
Rye Phillips
 courtesy West Models
 and Talent, Inc.
Bria Phillips
 courtesy West Models
 and Talent, Inc.
Nicholas Vento

Technicians in the hair-
 and skin-care
 photographs are from
 John Allen's Men's
 Club.

WARDROBE

Suits and Sport coats
Bernhard Altmann*
Bert Pulitzer*
Chaps by Ralph Lauren†
The Falke Group
Grays by Gary
 Wasserman†
Greif Studio
Hart Schaffner & Marx
Jeffrey Banks Studio
KM by Krizia
Kilgour, French &
 Stanbury†
Lanvin†
Perry Ellis†
Polo University Club by
 Ralph Lauren‡

Tuxedos
Chaps by Ralph Lauren†
Perry Ellis†

Shirts
At Ease by Enro Shirt Co.
Donberry and Keats by
 Enro Shirt Co.
Gitman Brothers Shirt
 Company
Hanes
Henry Grethel
Jeffrey Banks Studio
John Henry‡
KM by Krizia
Levi Strauss & Co.
Liberty of London‡
L.L. Bean
Nautica
Nino Cerruti‡
Pattinni Uomo by Enro
 Shirt Co.
Stile' by Gitman Brothers
Tommy Hilfiger

Sweaters
At Ease by Enro Shirt Co.
The Falke Group
Henry Grethel
Nautica
Tommy Hilfiger

Pants
At Ease by Enro Shirt Co.
The Falke Group
Henry Grethel
Jeffrey Banks
Levi Strauss & Co.
L.L. Bean
Nautica
Thomson Co.
Tommy Hilfiger

Ties
Gitman Brothers
John Henry‡
Liberty of London‡
Nino Cerruti‡
Pattinni Uomo by Enro
 Shirt Co.

Bow Ties
Gitman Brothers
Liberty of London‡

**Tuxedo Tie and
Cummerbund**
Liberty of London‡

Belts
John Henry‡
Liberty of London‡
Perry Ellis‡

Suspenders
John Henry‡
Liberty of London‡

Underwear and Robes
Jockey International Inc.

Socks
E. G. Smith
Jockey International Inc.

Foot Wear
Adidas USA
Bootz
Rockport
Walkover

Hats
Makins Hats

Outerwear
B. Free
Chaps by Ralph Lauren†
Grays by Gary
 Wasserman†
Greif Studio
Henry Grethel

Jeffrey Banks Studio
KM by Krizia
Levi Strauss & Co.
M. Julian
Nautica
Polo University Club by
 Ralph Lauren†
Tommy Hilfiger

Workout Wear
Everlast
Hanes
Jockey International Inc.
L.A. Sporting Club
Mighty Mac
Riddell Active Wear
Russell Athletic
10-S

WOMEN'S FASHIONS

Clothes
Bill Blass
Donna Karan
D.K.
Jockey for her
Mary McFadden
Nautica
Steven Stolman

Jewelry
D.K.
Erwin Pearl

Hats
Patricia Underwood

Shoes
D.K.
Vittoria Ricci

Watches by Alfex of
 Switzerland
Sunglasses by Ray-Ban

On the Front Cover:
Suit by Polo University by
 Ralph Lauren by the
 Greif Companies
Shirt by Pattinni Couture
 by Enro Shirt Co.
Tie by Liberty of London by
 Manhattan Menswear
 Group

SKIN CARE

Grooming Products
The hair- and skin-care
 products used in *Men*

of Style are all
environmentally
friendly and have not
been tested on
animals.
Caswell-Massey Ltd.
Kiss My Face
Shaklee Corporation
Vera Brown

Hair- and skin-care
 equipment from
 Caswell-Massey Ltd.

**ADDITIONAL CREDITS
AND LOCATIONS**

Cosmetic Surgery Advisor:
 Steven Herman, M.D.
Advisor for Basic
 Wardrobe Collection:
 Barry Van Lenten,
 Editor, DNR Magazine.
Grooming section
 photographed at
 John Allen Men's Club,
 New York City
Outdoor locations
 photographed at:
 Greystone, Millerton,

New York, courtesy
 Merrill Sindler and
 Alfred Lopez
Wall Street area and
 City Hall, New York
 City, courtesy New
 York City
Gurney's Inn,
 Montauk, Long
 Island, New York
Bushkill Falls, Bushkill,
 Pennsylvania
Indoor locations
 photographed at:
The home of the
 Reverend John
 Andrew, Rector of
 St. Thomas Church,
 New York City
The Zoli Agency
The Athletic Complex,
 New York City

Mural for food still life
 by Firebird, Inc.

* For the 500 Fashion Group
† by The Grief Companies
‡ by Manhattan Menswear
Group

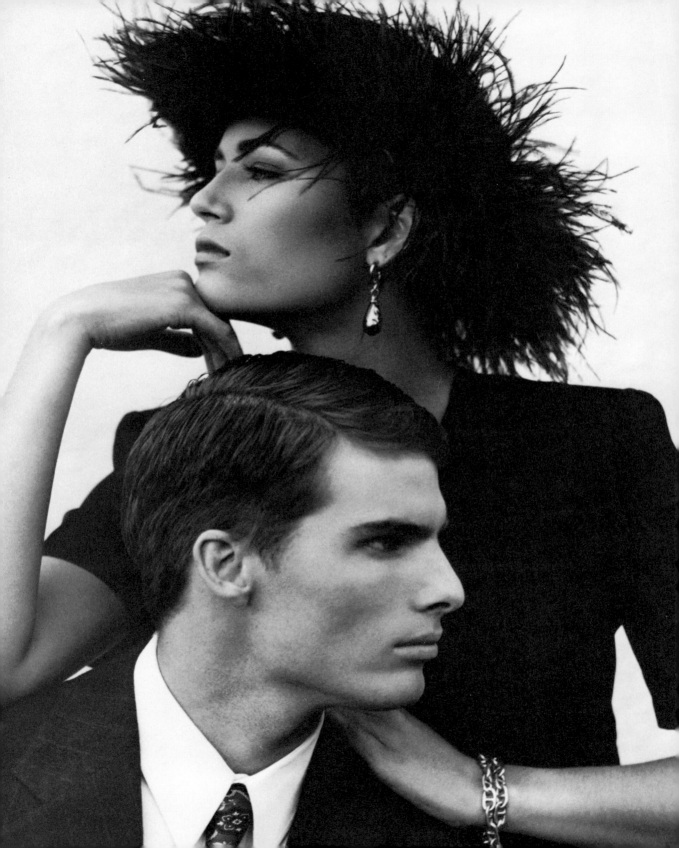

Index

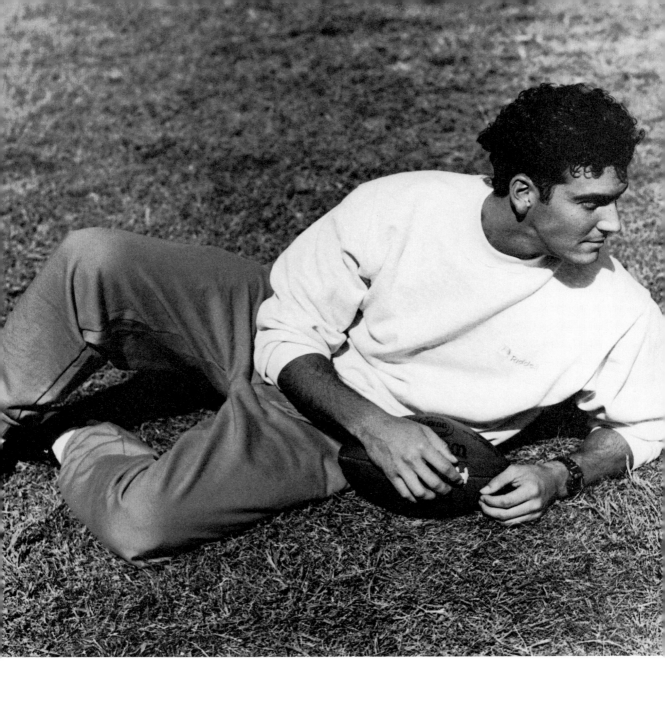

About the Author

DONALD CHARLES RICHARDSON is one of America's foremost writers on men's fitness, grooming, and fashion. His articles and columns have appeared in top publications such as *GQ, The New York Times, Men's Wear, MR, Weight Watcher's Magazine,* and the New York *Daily News,* among others. He is the author of *Balanced Body, Your Hair: Helping to Keep It, Croquet: The Art and Elegance of Playing the Game,* and three novels. Creative consultant for both *Exercise for Men Only* and *Men's Exercise* magazines, he lives in New York.